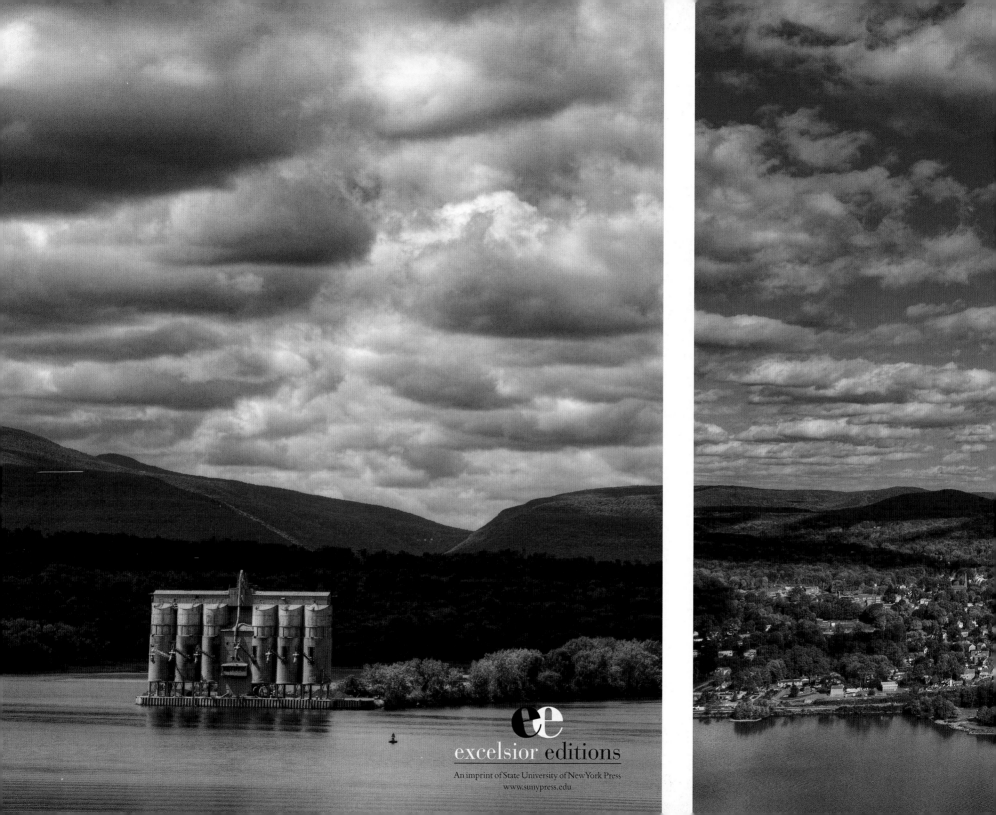

excelsior editions

An imprint of State University of New York Press
www.sunypress.edu

HUDSON RIVER TOWNS

Highlights from the Capital Region to Sleepy Hollow Country

PHOTOGRAPHS BY HARDIE TRUESDALE

TEXT BY JOANNE MICHAELS

To the people and organizations in the Hudson Valley who love their villages, towns, and cities . . . and especially those who have continually worked to preserve the scenic beauty and heritage we so often take for granted.

Published by
STATE UNIVERSITY OF NEW YORK PRESS, ALBANY

Text copyright © Joanne Michaels 2011
All photographs copyright © Hardie Truesdale 2011
All rights reserved

Printed in the United States of America

EXCELSIOR EDITIONS is an imprint of
STATE UNIVERSITY OF NEW YORK PRESS

For information, contact
State University of New York Press, Albany, NY
www.sunypress.edu

Production and book design, Laurie Searl
Marketing, Fran Keneston

Library of Congress Cataloging-in-Publication Data

Truesdale, Hardie.
Hudson River towns : highlights from the capital region to Sleepy Hollow country / Hardie Truesdale ; with text by Joanne Michaels.
p. cm.
ISBN 978-1-4384-3963-1 (hardcover : alk. paper)
1. Hudson River (N.Y. and N.J.)—Pictorial works.
2. Hudson River Valley (N.Y. and N.J.)—Pictorial works.
3. Hudson River (N.Y. and N.J.)—Description and travel.
4. Hudson River Valley (N.Y. and N.J.)—Description and travel.
5. Hudson River Valley (N.Y. and N.J.)—History, Local—Pictorial works. 6. Cities and towns—Husdon River Valley (N.Y. and N.J.)—Pictorial works. I. Michaels, Joanne, 1950– II. Title.

F127.H8T89 2011
974.7′3—dc22

2011010864

10 9 8 7 6 5 4 3 2 1

E-Commerce Square, Albany, above

Mathilda, Hudson River Maritime Museum, page i

Cementon cement plant, Hudson River, page ii

Cold Spring and Constitution Marsh, Hudson River, page iii

cover photograph: View of July 4th Fireworks over Nyack and Piermont, from Hook Mountain State Park

CONTENTS

ACKNOWLEDGMENTS

Hudson River Way Pedestrian Bridge

Our heartfelt gratitude to the people throughout the cities, towns and villages of the Hudson Valley and Catskills who have fought difficult battles against all odds to preserve the heritage and beauty of our historic region. A special thanks to everyone who played a part in bringing this book to fruition, including those who gave interviews and contributed their time, insights and memories: Kathleen Hickey at The Beacon Institute, Kathy Stevens at the Catskill Animal Sanctuary, Kristen Cronin at Cornerstone, Evelyn Trebilcock at Olana, Anthony Pellegrino at Philipsburg Manor and Kykuit, Jim Fox at West Point, Linda Pierro at Flint Mine Press, Scott Sailor at Bruised Apple Books, Lauren Dunn, Greg Helsmoortel, Karl Krause, Fred Schaeffer, Brad Rosenstein and Lori Selden. Additionally, several reference librarians and local historians throughout the Hudson Valley proved to be more helpful than any researcher could hope them to be.

We are also grateful to James Peltz, director of SUNY Press, for his continual support and patience. He was always willing to listen and was extremely responsive in overcoming the roadblocks encountered during the course of the publishing process. Enormous thanks are also due to production editor Laurie Searl whose assistance and suggestions were invaluable. No authors create a book alone and both James and Laurie were there for us from beginning to end.

INTRODUCTION

As the author of two guidebooks to the Hudson Valley that have been in print for over two decades, I continually travel throughout this scenic historic region. On these trips I often spend time in several of the villages and cities along the Hudson River. Each one of them has a unique ambiance and its own colorful history. And each is a dynamic entity, constantly changing.

Over the years, as I drove around the Valley I passed through cobblestone streets, explored the ruins of an old factory, or watched the renovation of a celebrated theater. I grew curious about the stories behind these buildings and historic sites and why the towns grew up where they did—an aspect of the region I had not yet delved into.

And so I set out on a journey that spanned from Albany, Kingston, and Poughkeepsie to Newburgh, Beacon, and Nyack, to name just some of the places award-winning photographer Hardie Truesdale and I have explored. The photographs and text here present only a glimpse of what these vital places have to offer. The book follows some of the major Hudson River cities, towns, and villages, from Albany in the north to Westchester and Rockland counties in the south, approximately half the 315 miles of the Hudson River.

In these busy hubs of the region, change is the only constant. Houses disappear, riverfront parks sprout up, and towns are transformed in one generation into totally different communities. Entire industries are lost, relocate, or are replaced by new technologies. One example of this phenomenon is the whaling industry of the city of Hudson that has left behind only a small collection of model ships at the local historical society. Nothing in the city today suggests the atmosphere of a whaling port.

Between 1820 and 1830, the Hudson Valley was the fastest growing region in the nation, and the Hudson River was the main artery of trade in America. The strategic importance of the Hudson River increased after 1825 when the Erie Canal was completed.

Every town and village from Manhattan to Albany had a fleet of sloops, and these graceful vessels dominated the river until 1807 when Robert Fulton introduced the steamboat. At the time, steamboats were cheaper and faster than sloops and they accommodated large numbers of passengers as well. But their heyday was short lived.

The Civil War marked the end of one period in Hudson Valley history and the beginning of another—the era of the railroads. By the end of the nineteenth century, accessible areas north of Manhattan had expanded greatly thanks to rail travel. Also between 1825 and 1875 the land area of the United States more than doubled and the population of the country more than tripled. The prosperous years of the Catskills were to a great extent a result of the rise of the railroads.

In the early twentieth century, the automobile evolved from a luxury item to a widely used vehicle for both pleasure and business and approximately 2,500,000 cars were registered. After state and federal highway systems were built, this led to increased interest in Hudson Valley real estate and tourism—and the demise of the railroads.

Critical events occurred in Hudson River towns; many of them influenced the course of American history. Interestingly, Kingston was the first capital of New York State, Poughkeepsie was the second, and Albany was the third. While I grew up near Peekskill where the Standard Brands plant employed 1,000 people, I never realized the significant role their yeast played in literally raising the bread of millions of Americans. The *Clearwater* originated in Beacon and the sloop has inspired citizens everywhere to become involved with environmental issues in their communities since its maiden voyage in 1969.

The four-hundredth anniversary of Henry Hudson's journey seemed like an appropriate time to look back as well as ahead. Over four centuries the Hudson Valley, once inhabited solely by Native Americans, developed into a densely populated commercial region rich in manufacturing but also in scenery and culture. The commerce of the Hudson River—and the towns that developed along its banks—was the lifeblood of New York State's economy for centuries. Water transportation made possible the limestone, cement, brick, and bluestone industries. The beauty of the region attracted tourists, writers, and artists. In the twentieth century when the river became heavily polluted by industrial waste, this damage was recognized, and efforts were undertaken to end it and revitalize the Hudson. Once again, the region is prospering, particularly through growth in tourism, and there is hope for a bright future.

Perhaps this book will spark the curiosity of readers to visit Hudson Valley towns and villages and discover more about their pasts as well as enjoy what they offer today. I sincerely hope this pictorial journey will lead you on as fascinating a trip as Hardie and I have experienced to the heart of our region, to the pulsing towns that have always been such a vital part of the Hudson Valley—and our nation.

SUNY Central Administration Building, left
Albany skyline, right

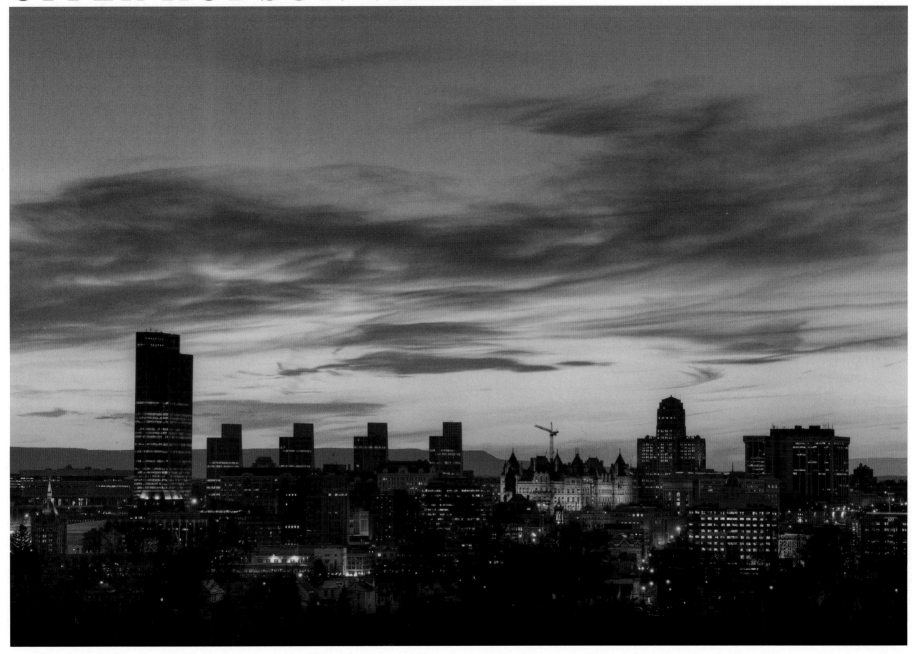

Albany

In 1609, while seeking a trade route to the Far East, Henry Hudson came upon "La Grande Rivière," the name given to the Hudson River by early French explorers in the mid-sixteenth century. The Dutch named the river for Henry Hudson, and in 1624 the first settlers, including French Walloons, began a colony named Fort Orange (where Albany is today) for the House of Orange, the royal family of the Netherlands. Soon the Dutch West India Company established a trading post at Fort Orange. And in 1652 Peter Stuyvesant, governor of New Netherland, changed the name of the settlement to Beverwyck.

In 1664 when the Dutch surrendered to the British without armed conflict, King Charles II granted New Netherland, New England, Long Island, and Delaware to his brother James, the Duke of both York and Albany. It was then that Beverwyck became Albany and New Amsterdam became New York.

When the Dutch explorers and traders arrived in the lower Hudson River Valley after the exploration of Henry Hudson in the early seventeenth century, they discovered a Native American economy that included farming, hunting, and gathering. The Native Americans raised corn, beans, squash, and tobacco; gathered berries; and hunted game. The arrival of the Dutch settlers enhanced and changed their basic economy. In the latter part of the seventeenth century the fur trade grew in importance. The settlers also introduced the concept of purchasing land—an idea that was entirely alien to the Native Americans and irrevocably changed their existence.

During the Revolutionary War period (1775–1783), Albany was a strategic location for planning military maneuvers and storing supplies. Albany residents Philip Schuyler, Peter Gansevoort, and Abraham Ten Broeck were all generals in the war. In fact, the Schuyler Mansion, now a state historic site, was where British

military officer General John Burgoyne was held after his surrender in the Battle of Saratoga, the turning point of the Revolution. George Washington, Alexander Hamilton, John Jay, and Aaron Burr were also guests at General Schuyler's home during the Colonial period.

In 1797 Albany became the permanent capital of New York State and throughout the nineteenth century Albany became an important transportation center, accessible by land via stagecoach and water by steamboat (after 1807). With the opening of the Erie Canal in 1825, goods could more easily travel westward. And in 1831 railroad travel began with the first trip between Albany and Schenectady. Twenty years later, one could travel by rail between Manhattan and Albany.

While Albany's history spans over four hundred years, few of its earliest historical structures have survived. Many Colonial and Revolutionary War era buildings were destroyed over the years. Some sites that did survive into the twentieth century were leveled and replaced by modern structures like the Empire State Plaza and the Times Union Center.

Located approximately midway between the source of the Hudson River at Lake Tear of the Clouds in the Adirondacks and Manhattan, Albany has had a colorful history. The song "Yankee Doodle" was written at Fort Crailo in the city in 1775. Robert Fulton's steamship, *Clermont*, made its first trip from New York City to Albany in 1807. The oldest church pulpit in America, carved in Holland in 1656, can be found in Albany's Dutch First Reformed Church. Four New York governors eventually became president—Grover Cleveland, Theodore Roosevelt, FDR, and Martin Van Buren—more than any other state. Erastus Corning II was mayor of Albany from 1942 to 1983, the longest single mayoral term of any major city in America. And perforated toilet paper originated in the city as well; Albany resident Seth Wheeler began selling it in 1877.

The Egg

The Egg, a landmark that defines the Albany skyline, is perched quite remarkably in the Empire State Plaza. Built between 1966 and 1978, it is not at all fragile. In fact, a concrete skirt surrounding the Egg is attached to a stem that reaches down six stories into the plaza to support the weight of this peculiarly inclined structure. Some visitors have noticed that once inside all sense of elevation and direction seems to disappear and a vague sense of disorientation sets in.

How did this distinctive creation come to be? City legend claims the birth of the Egg occurred at the breakfast table. One morning when Governor Nelson Rockefeller was dining with Empire State Plaza architect Wallace Harrison, they discussed the need for a building that would break up the vertical lines of the towers on the plaza. The governor looked down at the half grapefruit on his plate and placed it on a small pitcher of cream. "It should look like that!" he said. And Harrison, inspired sufficiently by the governor's vision, carried it out.

Construction costs ran close to 100 million in 1970 dollars and the building was called The Meeting Center since its intended use was for government meetings in the capital. After completion, however, people immediately began referring to it as the Egg; eventually the name stuck and became official. The building was extremely controversial at the time and one critic described it as a "futuristic Italian bidet." Today, most of us can't imagine the city of Albany without the Egg, a popular performing arts venue and cultural treasure. The design continues to be a subject of intense disagreement: some love the building and others feel it is devoid of any artistic value.

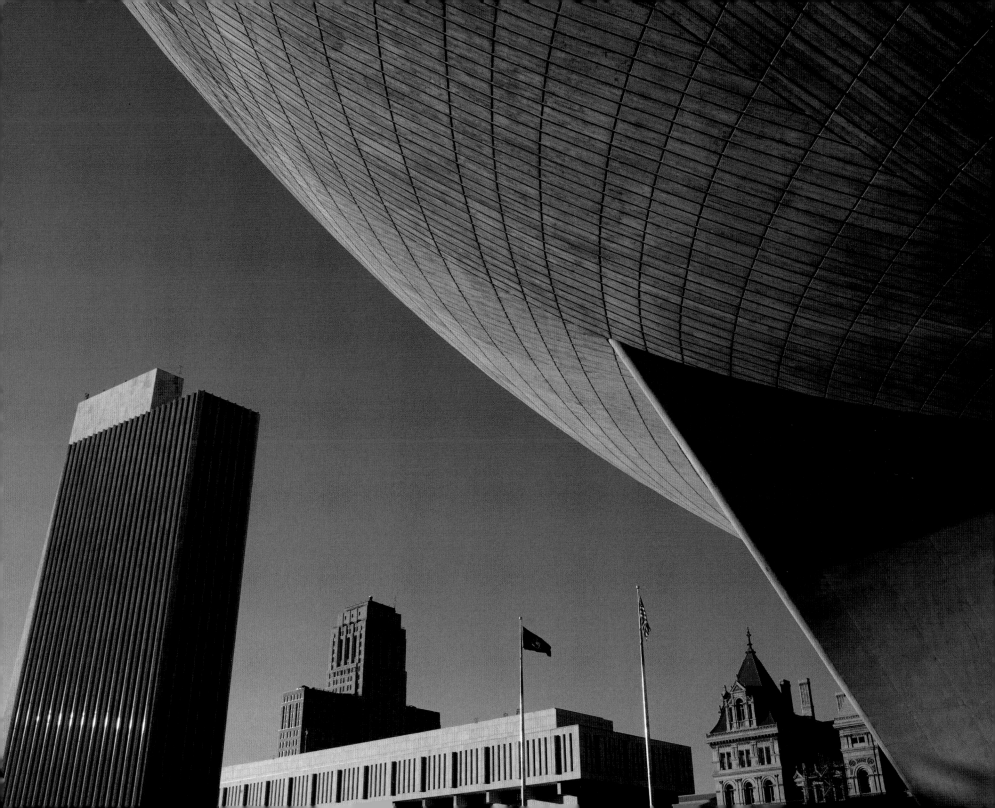

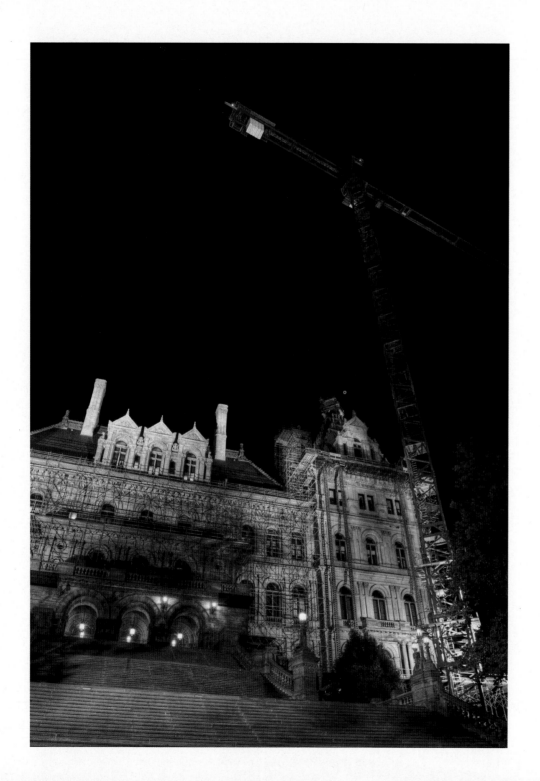

New York State Museum

Anchoring one end of the Empire State Plaza, the New York State Museum has been an integral part of the state's history since 1836, making it one of the oldest museums in America. A wonderful destination for young children, it is chock-full of multimedia presentations and interactive exhibits that bring to life the changing face of the Empire State over the centuries.

Capitol Building

For visitors to Albany, a tour of the Capitol building is a must. One of the highlights of the tour is the Great Western Staircase, also known as the Million Dollar Staircase, perhaps the most renowned of all the building's embellishments. Completed in 1881, it took several years to construct this 119-foot-high staircase made of Corsehill freestone imported from Scotland. To do the job, 600 stone carvers were hired to hand-carve 77 famous faces into the pillars. Some of them are George Washington, Abraham Lincoln, Thomas Jefferson, Alexander Hamilton, Benjamin Franklin, Christopher Columbus, Susan B. Anthony, Walt Whitman, and Harriet Beecher Stowe. Once these renowned Americans were carved, the artisans were permitted to include the faces of friends and family members, and they did. These carvings are known as the "Capitol Unknowns."

Cityscape

Albany is privileged to have some of the most beautiful sunsets year-round, and the skyline looks particularly dramatic at dusk during the icy-cold winters. Calm settles over the city at the end of the day as it empties out and people head north, south, east, and west. Many people think of Albany as a government town but it is a

State Capitol Building, Albany

dynamic city, a mosaic of architectural styles and a melting pot of nationalities, firmly rooted in history yet continually changing. It is a city of lively neighborhoods, each with its own distinctive character, melding past and present at every turn.

College of Nanoscale Science and Engineering

The College of Nanoscale Science and Engineering of the University at Albany is the first college in the world dedicated to research, development, and education in the emerging disciplines of nanoscience, nanoengineering, and nanoeconomics. Founded in 2001 and combining the vision of government, academia, and industry, over 5.5 billion dollars has been invested in this complex; there are over 250 global corporate partners making this center the most advanced research complex at any university in the world.

Tulip Festival / Pinksterfest

The oldest chartered city in the United States, Albany is also the second oldest continually inhabited settlement in America, an important river stop and trading center. A visit to the city today reflects Albany's Dutch origins. The Pinksterfest, a weekend celebration in May, welcomes the spring in the Dutch tradition complete with tulip festival.

The Tulip Festival is centered around Washington Park where over 200,000 blossoms, a magnificent sea of color, featuring 140 different kinds of tulips, usher in spring. This annual celebration of the city's rich Dutch heritage dates back to July 1, 1948, when Mayor Erastus Corning passed a city ordinance designating the tulip as the official flower of Albany. He asked Queen Wilhelmina of the Netherlands to select a type of tulip to be the flower of the city. She chose the "Orange Wonder." The following spring, in May 1949, the first Tulip Festival took place in Albany and the event has grown over the decades. A couple of traditions, however, have remained the same. A Tulip Queen is crowned by the mayor in Washington Park with a festive Tulip Ball following in the evening. The opening ceremonies always begin with the scrubbing of State Street. In Holland, streets were always thoroughly cleaned in this manner before

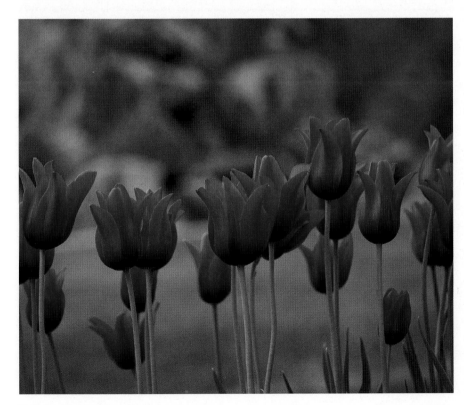

Tulips in Washington Park

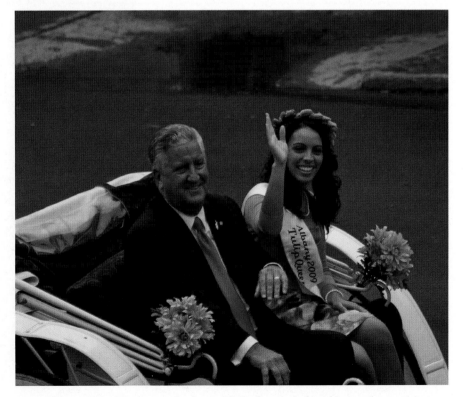

Albany Mayor Jerry Jennings and a former Tulip Queen, Juliana Hernandez, at the 2010 Tulip Festival, Washington Park

any celebration. The original Dutch streets were dirt and cobblestone and the scrubbing removed what the horses left behind. These days the Tulip Festival is a free family-friendly event welcoming everyone with outdoor entertainment, food vendors, crafts, clowns, music, and activities for children. Of course, the strikingly beautiful tulips are the stars of the show!

Washington Park

The 90 acres known today as Washington Park have been used as a recreational site in Albany for over 300 years and it is still a tranquil place for both old and young Albanians to enjoy. The King Memorial Fountain (as in Henry L. King, a citizen of Albany who bankrolled

Fresh Roses, Tulip Festival

King Memorial Fountain, Washington Park

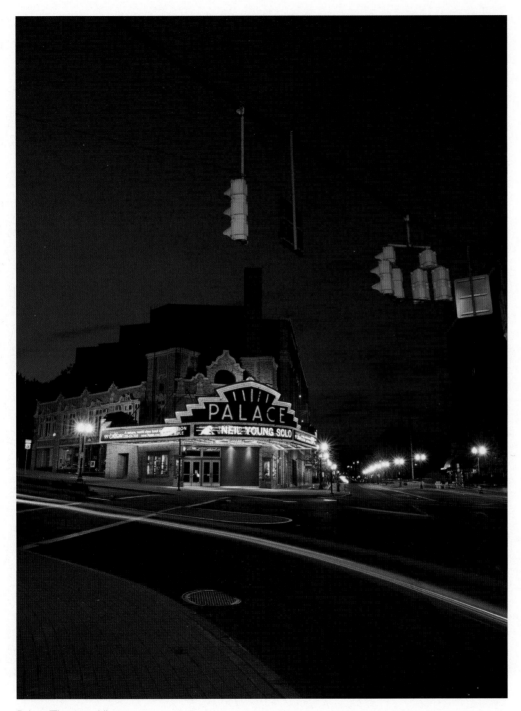

Palace Theatre, Albany

the sculpture created by J. Massey Rhind) dates back to 1893. There is a lake and playground, but the children enjoy exploring all kinds of venues. Climbing around the inviting fountain, they are undoubtedly oblivious to the stone figures representing Childhood, Youth, Manhood, and Old Age.

Palace Theatre at Night

When the 2,844-seat Palace Theatre opened in October 1931, it was the third-largest movie theater in the world. Designed by John Eberson, the Palace is a stunning example of his trademark atmospheric theaters. Such movie palaces have an auditorium ceiling that gives the illusion of an open sky. Another defining feature is that the opulent decorative and architectural elements convey the feeling of an exotic locale. The style caught on during the Depression when not only the film itself, but the surroundings, allowed people to feel they had escaped from the grim reality of the era, if only for a few hours. Eberson designed about 500 such theaters in America.

Today the renovated Palace in Albany is on the National Register of Historic Places; it hosts first-rate talent from the worlds of music, drama, and comedy. The Rolling Stones played at the Palace in 1965 on their third American tour. In recent years, Chelsea Handler, Neil Young, and Melissa Etheridge have all performed in this magnificent venue that is also home to the Albany Symphony Orchestra.

Pedestrian Bridge and Albany Riverfront Park at Corning Preserve

If visitors or residents desire to escape the hustle and bustle of the capital, they can simply walk over the Hudson River Way Pedestrian Bridge and soon they

Compass Wheel, Mohawk/Hudson Bike Trail

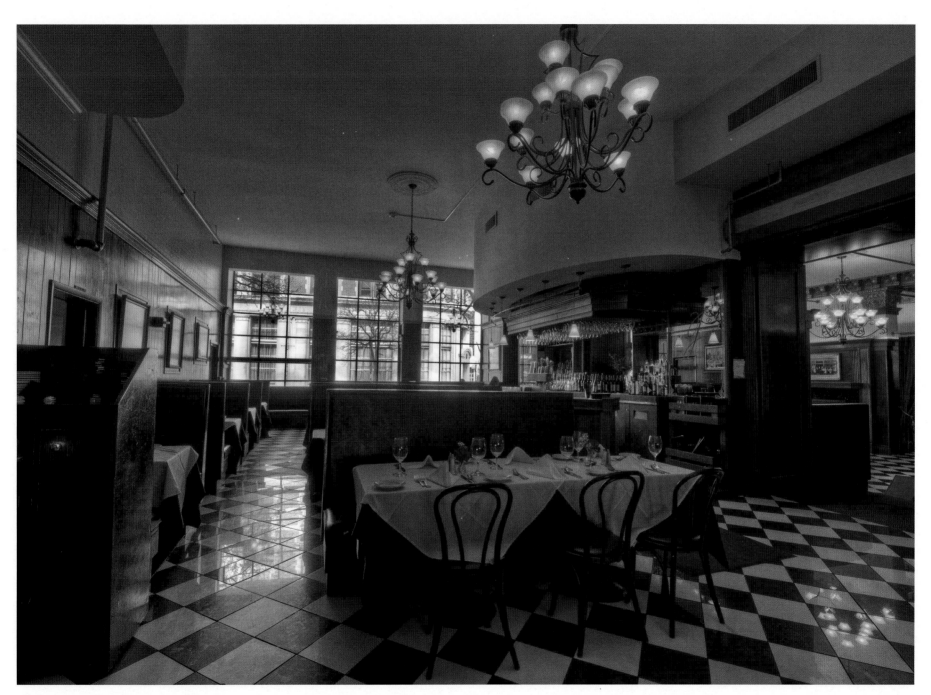

Jack's Oyster House, State Street, Albany

will be in a beautiful riverfront park, a lovely place to walk, bike, and picnic. There is an enormous compass wheel to explore as well as an 800-seat amphitheater, making this a scenic hub for urban recreation and culture in the capital.

Jack's Oyster House

An integral part of the city's culinary landscape, Jack's Oyster House is Albany's oldest restaurant, dating back to 1913. That is the year when Jack Rosenstein, a former oyster shucker, started his own business. For nearly a century the restaurant has been owned and operated by the same family; grandson Brad Rosenstein has preserved the restaurant's traditions yet also made innovative changes to attract a new generation of patrons.

Originally located at the corner of Beaver and Green streets, in 1937 Jack moved the restaurant to its present location at the foot of State Street. It's a short walk down the hill from the Capitol Building, easily accessible to both lawmakers and downtown residents. The wood paneling in the dining room of this city landmark is original, and the photographs decorating the walls reflect the Albany of an earlier era.

Coxsackie—Bronck Museum / Oldest Multi-Sided Barn

In 1662 Pieter Bronck, a relative of the man who settled the Bronx, purchased land known as "Koixhackung" (Coxsackie) from the Katskill Indians. (Interestingly, the pronunciation is supposed to resemble "the hoot of an owl," which is the translation of the Indian word Coxsackie). Little did Pieter know the land would become a working farm and home to eight generations of Broncks over the following three centuries. In 1939 Leonard Bronck Lampman, the last family member

to own the farm, donated the eleven structures and surrounding acreage to the Greene County Historical Society.

The original stone house with large beams, wide floorboards, and a Dutch door is the oldest surviving dwelling in Upstate New York. As the family grew in size and affluence, additional buildings went up, including a 1785 Federal brick house and three barns. In the early 1800s, the Bronck farm was the most valuable single property in the county. With an interest in new farming methods, the family switched from raising wheat to dairy farming, and by the 1830s had constructed an innovative barn. This historically and architecturally significant complex includes one of the most interesting structures to be found anywhere—the oldest multi-sided barn in New York State. The weight of the roof rests on its thirteen sides. The interior contains only a single center pole! The farm serves as the headquarters for the Greene County Historical Society and has been designated a National Historic Landmark.

Athens

The village of Athens may be one of the sleepiest small towns in the region, but it offers some of the easiest access to the Hudson; its unpretentious Riverside Park with benches and a pavilion offers incredible views to those who make a detour off Route 9W. Once a bustling shipbuilding town with thriving businesses like the Athens Shipyard, Clark Pottery, the Every & Eichhorn Ice House, Howlands Coal Yard, and several brickyards, Athens was the point of origination for a number of ferries that ran between the dock and the city of Hudson from 1778 until the 1940s. When the Rip Van Winkle Bridge opened in 1935, the demise of ferryboats soon followed.

In the summer and fall during the nineteenth century, farmers like Cornell Vosburgh, who had a large

truck farm north of town, shipped produce by boat to New York City for sale. During the winter months, ice cutting was an important industry in Athens. There were nine icehouses lining the waterfront in Athens and they provided off-season work for farmers and workers in the brick industry.

Tucked away in the village of Athens is Elco, the company that introduced the electric engine to boating in the nineteenth century. The electric motor boat was first demonstrated at the World's Fair in Chicago in 1893 when 55 of Elco's electric boats transported over one million passengers on Lake Michigan. Although they faced difficult times after World War II, today Elco is involved in restorations of old boats and remains one of the most significant companies in American boating history. And the future looks bright for this environment-friendly manufacturer, far ahead of its time, that consistently used electricity rather than diesel to power its boats.

The village is perhaps best known in recent years for the seven minutes it appears in Steven Spielberg's *War of the Worlds* (2005), starring Tom Cruise and Dakota Fanning. Many townspeople participated as extras in the production and a Hudson Ferry, complete with a huge dock, was created especially for the film . . . and was dismantled before the film crew left town.

Hudson-Athens Lighthouse

In Colonial times, midstream in the Hudson River, between the towns of Athens and Hudson, there were large mud flats, known as Middle Ground Flats. They were completely submerged at high tide and often ships would become stranded there. To avoid this situation and guide ships through this hazardous area, the "Hudson City Light" was opened in 1874. Pilings were driven down 50 feet into the riverbed, then topped by a granite pier. To protect the foundation from ice floes, the north

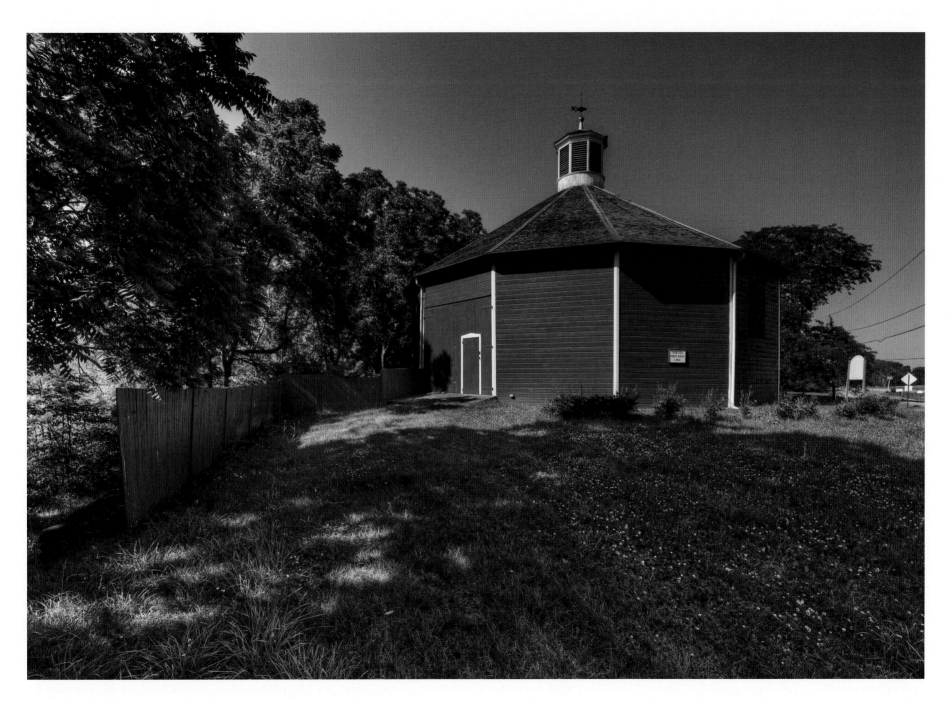

Thirteen-sided barn, Bronck Museum, Coxsackie

Athens Waterfront, Hudson River

end of the base was shaped like the prow of a ship. A two-story brick structure was built on the granite foundation. The last civilian keeper of the lighthouse retired in 1949 when the lighthouse was automated. Over the centuries, with silt being deposited, the mud flats have become an island.

Hudson—Warren Street

The city of Hudson's colorful past includes a potpourri of Dutch settlers, Quakers, merchants, and whalers. In 1783 a large group of seafaring Quakers arrived in Hudson from Nantucket and Martha's Vineyard in search of an inland harbor inaccessible to the British Navy and marauding pirates. They intended to create a whaling and trade center in Hudson; along with these enterprises came sailors and businessmen, a transient population that patronized taverns, and houses of prostitution.

During the early twentieth century, the city

became notorious for its numerous bars and bordellos; most were located at the southern end of town on Columbia Street, known as Diamond Street at the time. When whaling, railroads, and steamboats declined, Hudson went from a seaport to an industrial city. Where there had been tanneries, foundries, and breweries, soon there were knitting mills and brickyards. But Hudson went into a gradual decline during and after the Depression, and by the 1960s poverty and crime were widespread. In the early 1980s the gentrification of Warren Street began with the arrival of antique shops from Manhattan seeking satellite stores. Gradually art galleries, classy restaurants, and inviting B&Bs followed, and with these enterprises, real estate values rose.

The city of Hudson is home to the American Museum of Firefighting, dedicated on Memorial Day 1926, which contains the oldest and broadest collection of firefighting gear and memorabilia in America today. Horse-drawn and steam- and gas-powered pieces of equipment are on display and some date from the eighteenth century. A recent addition is the September 11th memorial display, filled with photographs, that lists the names of all the firefighters who lost their lives that day.

One of the most interesting businesses in Hudson is the Spotty Dog Books & Ale, a combination book and art supply store as well as coffee shop/bar/lounge housed in a former firehouse. This eclectic enterprise is also a venue for local bands to perform and authors and poets to read from their work. Carrie Nieman Culpepper of the *New York Times* notes that "Hudson now boasts a robust grassroots music scene and several musicians are settling in the city attracted by the progressiveness of the community."

An unusual aspect of Hudson is that throughout its fairly turbulent history, the city retained its architectural

Athens Riverside Café

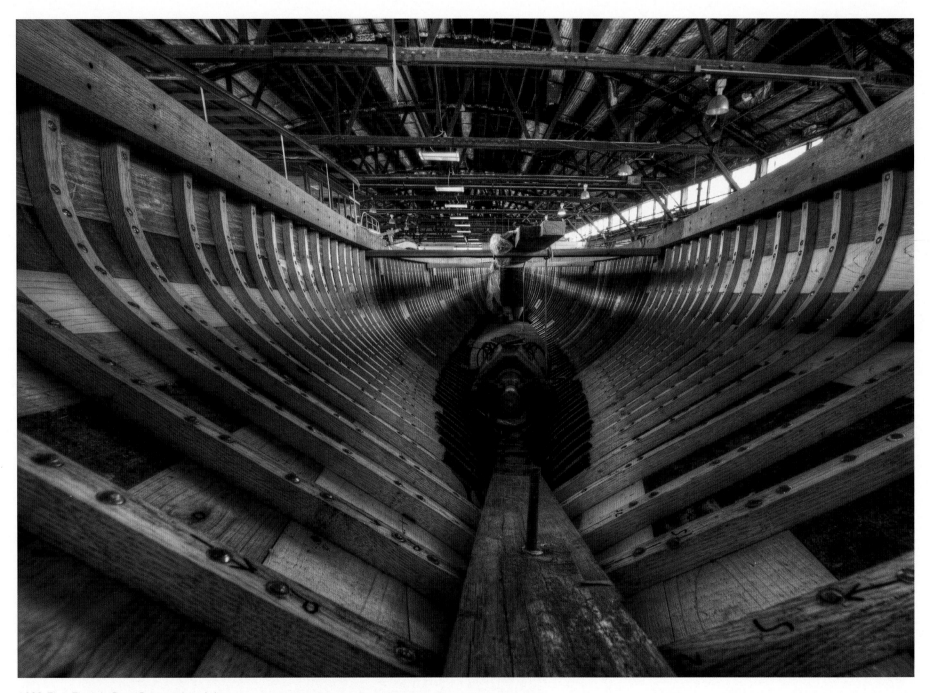

1893 Elco Electric Boat Restoration, Athens

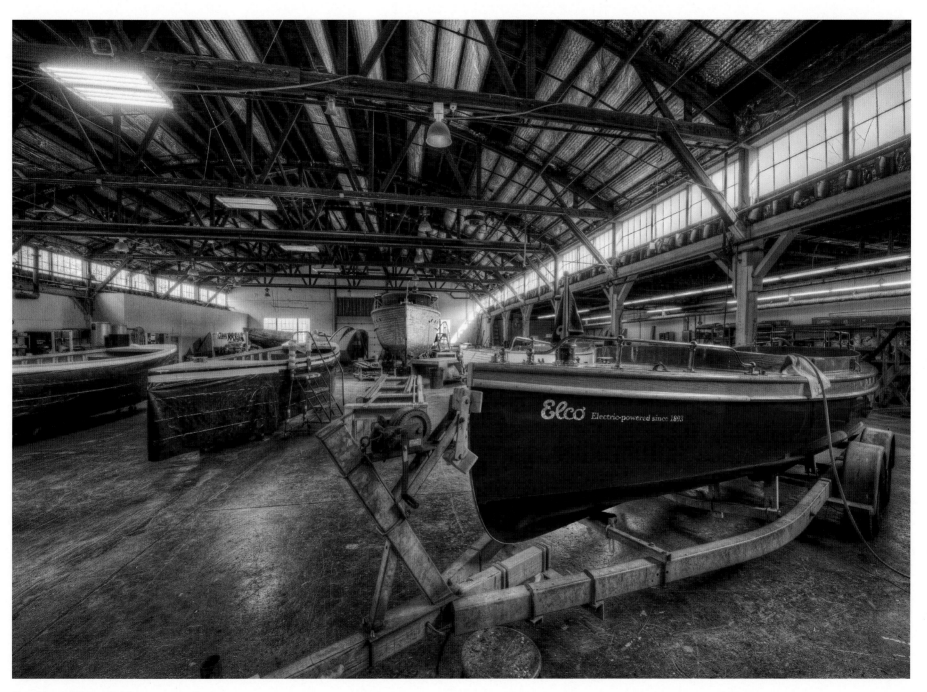

Elco Motor Yachts, Athens

Hudson-Athens Lighthouse

Renovations on Warren Street, Hudson

heritage. The length of Warren Street—nine blocks—showcases many distinctive styles in its public, religious, and banking institutions, three- and four-story commercial buildings, and late nineteenth- and early twentieth-century row houses. Today Warren Street is renowned as a hub of culture in the Upper Hudson Valley. Instead of tearing down the old structures, this latest wave of new residents retained the city's charm and renovated these architectural treasures, maintaining their integrity and giving the city its distinctive flair.

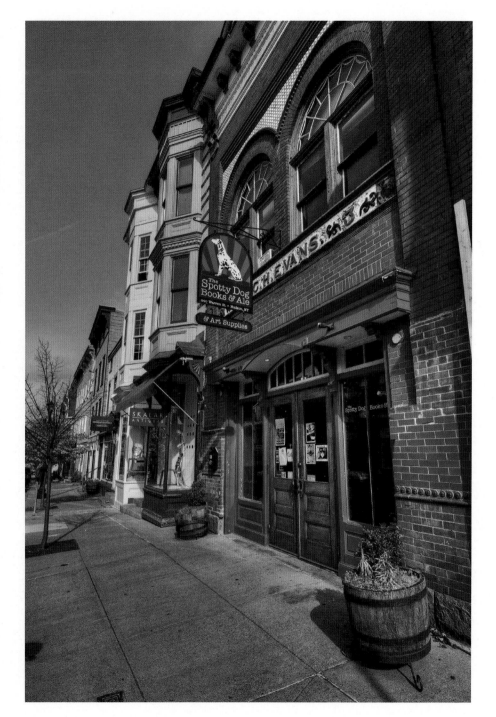

The Spotty Dog Books & Ale, Warren Street, Hudson

Gay Pride Parade, June 20, 2010

In recent years Hudson's gay community has grown in size and political power. Since the 1980s several men and women from metropolitan areas settled in Hudson, opened antique shops, restaurants, and galleries, and restored many of the city's historic homes. A number of these newcomers were gay. In 2010 Hudson hosted its first gay pride parade, a colorful event commemorating the Stonewall riot and reflecting the diversity of the community and its spirit.

This Hudson Pride celebration included a talk by Ed Beatty, who was part of the 1969 riot where gay people at the Stonewall Bar in Manhattan clashed with police who tried to disperse their gathering. This was one of the major events that led to the abolition of a law preventing gay citizens from congregating. In attendance at the Hudson Pride celebration were a number of politicians, proud to be part of the gathering, reflecting the recent changes in Hudson and New York State.

Blue Window

The Second Show is a community thrift shop with secondhand clothing, books, and all kinds of unusual finds. Their eclectic shop windows are continually changing—and are always intriguing.

Mexican Radio Restaurant

In 2003 Lori Selden and her husband, Mark, opened Mexican Radio in Hudson. They own another restaurant by the same name in Manhattan. The couple had

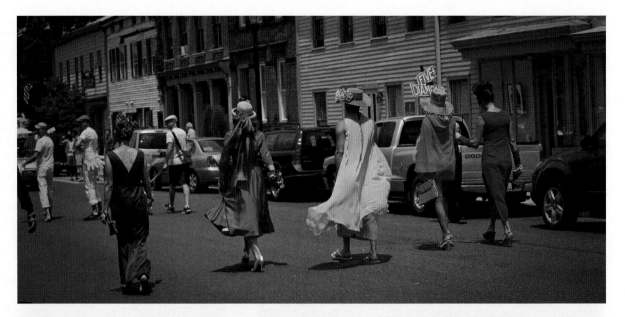

Gay Pride Parade, Warren Street, Hudson

Second Show, Warren Street, Hudson

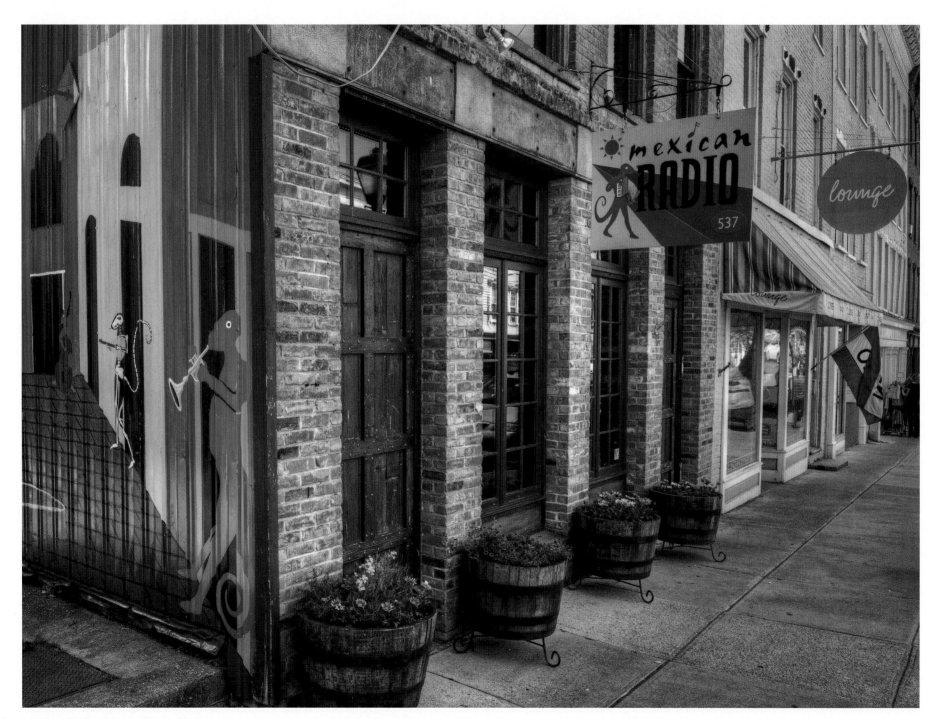

been visiting Columbia County for years and finally moved upstate. It was only a matter of time before the couple "found a brick building on Warren Street in Hudson that reminded us of our NYC restaurant, gutted it from the ground up, and nine months later, voila, Mexican Radio HUD was born!"

The restaurant uses lots of fresh local ingredients and has received accolades for its authentic cuisine, superb margaritas, and colorful atmosphere. Lori is usually there to welcome diners who often travel some distance to Hudson for the imaginative fare and festive ambiance.

Parade Hill / Promenade Park

Parade Hill and Promenade Park was originally where the earliest settlement in Hudson was located in the late eighteenth century. Many buildings were destroyed due to urban renewal programs in the early 1970s. Today

Margaritas at Mexican Radio, Warren Street, Hudson

Promenade Park provides a pleasant retreat from the commercial atmosphere of Warren Street. Unlike many Hudson Valley towns settled by the Dutch as agricultural centers, the downtown in Hudson followed a grid plan popular in New England, where the city's founders were from. Warren Street is one of the few intact nineteenth-century commercial streets in New York State today.

Olana

As a young man, Frederic Church (1826–1900) studied landscape painting with Thomas Cole at Cedar Grove, across the Hudson River in Catskill. Cole once remarked that Church had "the finest eye for drawing in the world." The Persian-style home of this renowned Hudson River School artist is perched high on a hill with magnificent panoramic views of the Hudson River, Catskill Mountains, and surrounding countryside. Church and his wife, Isabel, whom he married in 1860, named the estate after a fortress in ancient Persia that also overlooked a river valley.

In 1870 the Churches returned from extensive travels throughout the Middle East and Europe to their farm in Hudson intending to raise a family, and began planning and building the Persian fantasy that would become known as Olana. They hired the architect Calvert Vaux, who with Frederick Law Olmsted had designed Central Park, and Church worked closely with him. The magnificent 37-room mansion situated 460 feet above the Hudson River includes hand-painted tiles on the roof and turrets that add touches of green and pink to the sky. Church called his style "personal Persia,"

Parade Hill / Promenade Park,
Warren Street, Hudson, left

Olana State Historic Site, right

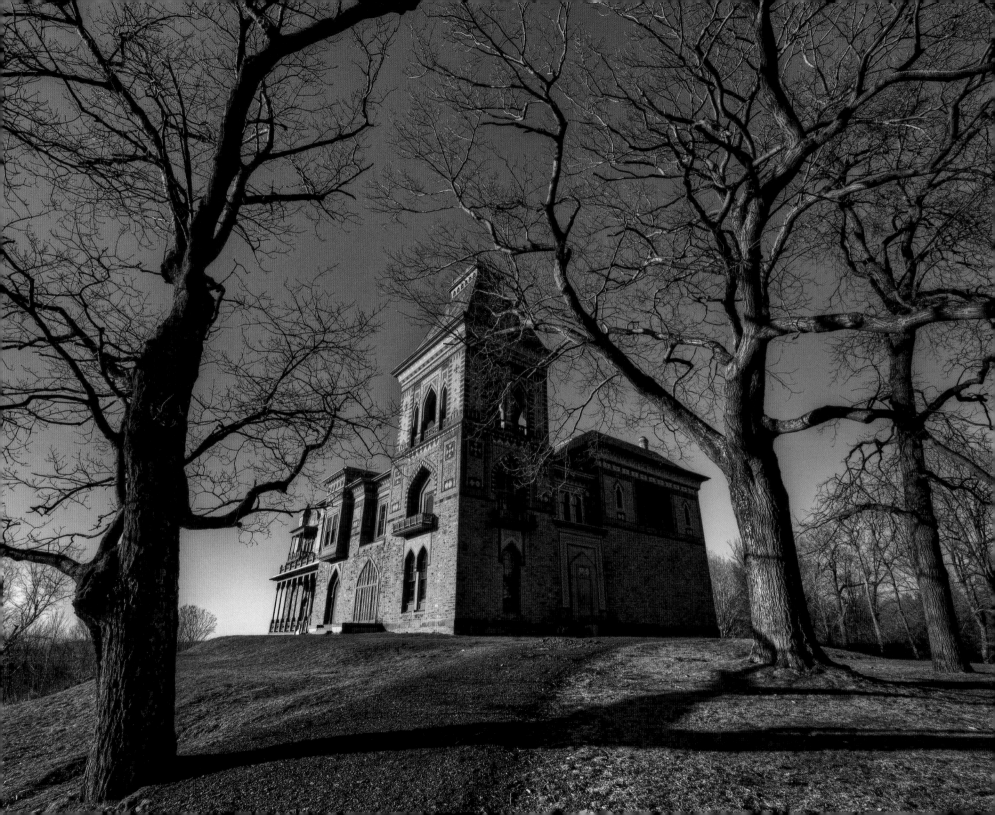

and inside there are hand-carved, room-size screens; rich Persian rugs; delicate paintings; even a pair of gilded crane lamps that look as if they stepped out of an Egyptian wall painting. Olana is also rich in examples of Church's paintings, including *Autumn in North America* and *Sunset in Jamaica*. His studio is still set up exactly as it was in his time.

Church wanted the interior of the structure to be in harmony with its surroundings, and the landscape surrounding Olana is particularly spectacular. Church laid out miles of paths as he created his living landscape, a lasting inspiration for his paintings. He felt that the grounds at Olana were just another form of canvas and he derived a great deal of satisfaction from creating roads through his lands. Visitors can walk year-round along the carriage paths that wind through the property and sense the same magic, mystery, and sheer beauty that endeared Olana to Church.

Barns of Olana

Wagon House Education Center at Olana is a series of barns that are home to public programs, classes, and lectures in a space with enormous glass windows overlooking the property's dramatic landscape.

General Frederick Osborn, grandson of railroad tycoon William Henry Osborn, ensured the preservation of Olana as a State Historic Site under Governor Nelson Rockefeller. Frank Kelly, director of the National Gallery of Art, described Olana as "the single most important artistic residence in America and one of the most significant in the world."

Rip Van Winkle Bridge

The Rip Van Winkle Bridge, 5,040 feet long, was completed in January 1935 at a cost of 2.4 million dollars

Barns of Olana

Dutchman's Landing, Catskill

Bridge Street, Catskill

Old Railroad Bridge, Catskill

Catskill

In recent years, a national magazine listed the town of Catskill as one of the most desirable places to live with a population of less than 10,000. The village is attracting artists and professionals with its affordable Victorian homes, galleries, variety of shops and restaurants. Additionally, there is easy access to the Hudson River, a plus for boaters who can dock at the marina and easily walk to the village. In the 1980s, Main Street was lined with empty storefronts. Today, a Renaissance has resulted in the arrival of new businesses and a revived real estate market. The village is a vibrant, thriving community.

Mining, lumber, and tourism were what made Catskill prosper in the nineteenth century and the town grew quickly from 1800 to 1825. According to *The History of Greene County*, "In 1787 there were five houses, one store and two sloops. Fifteen years later there were 180 houses, 12 warehouses, 31 stores, 15 vessels and 2000 people." The town was important in moving agricultural products to New York City and Boston. Just outside the village there were some of the largest flour mills in the state.

Until the tanning industry developed in the early nineteenth century, the area was thick with hemlock trees. The first business using hemlock bark for curing hides was founded in Athens and the first tanneries appeared by Kaaterskill Clove in 1817. Hides were imported from South America and elsewhere, cured in the mountains, and taken by wagon to Catskill and then downriver to New York City. By the end of the nineteenth century, however, the tanning industry was in decline and hardwood trees began to grow in the barren forest areas. In the 1890s, elegant brick buildings with ornate façades lined Main Street.

There was a period of decline in Catskill following the Depression into much of the twentieth century.

and three lives. When the bridge was opened, a toll of 80 cents per car plus 10 cents for each passenger was charged, making today's toll of $1.00 a comparative bargain. About 15,000 vehicles cross the bridge daily. While bicycles are permitted, they must share the roadway with motor vehicles. There are narrow sidewalks on both sides of the bridge that are reserved exclusively for use by pedestrians.

Interestingly, the Catskill approach was going to be built on land owned by Thomas Cole. The state offered to pay $15,000 for the land. The heirs of Thomas Cole believed the land was worth at least $100,000. In order to expedite the construction, the state located the approach north of the Cole property.

During the 1980s the removal of blighted postindustrial sites, "brownfields," and their reinvention as parks became part of New York State's cleanup efforts. At Catskill Point, an oil tank area was purchased by the state and replaced with a city park. Today Catskill has been revived; many of the structures in the village have been restored with the support of a new wave of residents who appreciate history and architecture.

Greene County Courthouse

The classical sandstone county courthouse is a magnificent structure on Catskill's Main Street that dates back to 1908. Designed by William A. Beardsley of Poughkeepsie, the building is topped with an ornamental balustrade. Four Ionic columns support the pediment, on which the bas-relief symbolizes the progress of civilization under rule of law.

This building was the center of county government for almost a century and served as the county's repository for deeds, mortgages, and court records. The building has a rich history of formal ceremonies that have taken place on the top platform of the long flight of stone stairs leading to the entrance. Governor Nelson A. Rockefeller and Senator Robert Kennedy are among those who have addressed crowds from these heights. A new Greene County Office Building was constructed at the beginning of the twenty-first century but the old building was renovated and this is still where court is held.

Catskill Point

With a boat launch ramp, barbecues, picnic tables, a playground, and Saturday farmers market (in season),

Greene County Courthouse, Catskill

Down by the Hudson River, Catskill Point

Dutchman's Landing, also known as Catskill Point, is a lovely spot to relax, spend a summer day, and take in the striking river views.

Painted Cat (The Catcher)—Main Street, Catskill

This is one of the 60 painted fiberglass felines, each about 28-inches high, displayed from Memorial Day weekend through Labor Day on Main Street in Catskill. In fact, these Cat-n-Around Catskill creations have attracted travelers to town who might have bypassed the village. The cats are imaginatively painted and decorated by area artists with local businesses sponsoring each one. There are cats with flags, angels, Cat'n Hook, as well as cats dressed in blue jeans, police uniforms, and top hats. This cultural event isn't simply a boon for tourism, but it unites the community, showcases local merchants, and emphasizes the role the arts have played in local history. At the end of September, the cats are auctioned off at the Cat's Meow Auction and Gala. In 2009 the auction grossed $80,000; the artists receive 30 percent of the funds brought in by their cat. The rest of the funds are distributed to various not-for-profit organizations in Catskill. The event was so successful during its debut in 2008, that Cat-n-Around Catskill has become an annual town tradition.

Cedar Grove / The Thomas Cole National Historic Site

Looking at Cedar Grove today, it is hard to imagine this modest homestead was the birthplace of a school of American landscape painting that inspired a monumental movement in the art world—the Hudson

The Catcher by Chad Weckler, Main Street, Catskill

River School. An otherworldly light shines from some of Thomas Cole's paintings and seems to transport the viewer back to childhood when the natural world was first glimpsed with innocence and enthusiasm. He showed nature in its raw beauty.

Cole was born in England in 1801, raised in Ohio, and studied art in Philadelphia before moving to New York City. It was there that George Bruen, a wealthy New York tea merchant and patron of fine art, subsidized Cole on a summer sketching trip to the Catskills in 1825. Not only did this trip change the course of Cole's life, it would eventually change the way the world viewed the Catskills. Cole settled permanently in Catskill in 1834 where he painted and taught landscape painting; two years later he met and married Maria Bartow, a niece of the owner of the farm Cedar Grove where he rented his studio. They had five children. At the end of his brief life (he died at the age of 47 from pleurisy), Cole left behind many journals and poetry in addition to an influential body of artwork. He imparted his knowledge to his star student, Frederic Church, who would carry on the landscape painting tradition at Olana, directly across the Hudson River from Cedar Grove.

Early Tourism—Catskill Mountain Houses

In the nineteenth century it was commonly believed America couldn't compare with Europe for great scenery. However, the paintings of the Hudson River School artists popularized the Catskills as a tourist attraction. The work of these painters created a sense of nationalism, and people sought to visit the intriguing places they saw depicted in the artwork. Pride in the American

Cedar Grove, The Thomas Cole
National Historic Site, Catskill

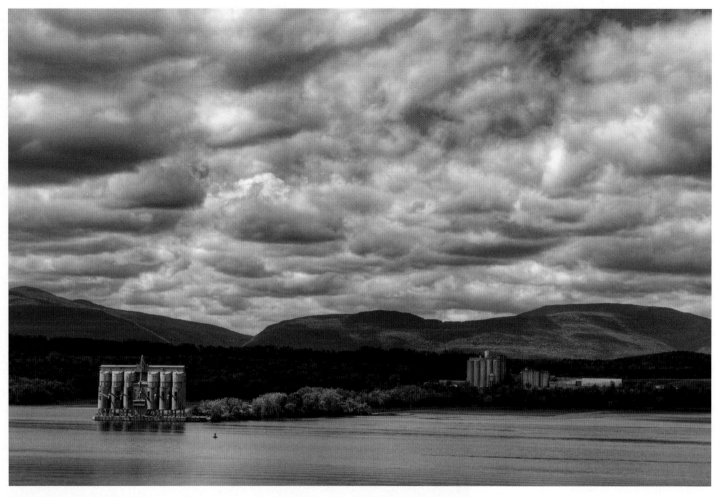

Cementon cement plant, Hudson River

landscape rivaling that of Europe became the prevailing sentiment, and the Catskills became a fashionable place to spend summer vacations. An increase in the number of middle-class people with time and money to spend, coupled with the fact that the region was accessible by rail and steamboat from New York City, led to a growing number of vacationers. The Catskill Mountain House opened in 1824 and was considered the premier hotel. Visitors were attracted by the elegance and luxury of the establishment as well as the spectacular scenery.

The success of the Catskill Mountain House and its satellite boardinghouses meant a great deal to the business community of Catskill. Supplies for the mountain house were bought in the village and Catskill residents found work there as well. Prospective guests on the mountaintop landed in Catskill from Hudson River steamboats and spent money while waiting for the stagecoach to take them on the four-hour journey up the mountain. The businessmen of other Hudson River towns within easy distance were envious as their Catskill rivals prospered. In Kingston, particularly, there began talk of building a hotel on Overlook Mountain to cash in on the lucrative tourist trade. This occurred, but not until 1871. Eventually, fire, changing ideas about leisure, and a downturn in the economy destroyed the mountain houses, but the region retained its place as a recreational destination.

Cement Industry

The Glens Falls Lehigh Cement Company, founded in 1893, is the oldest continuously operating cement manufacturer in New York State with plants in Glens Falls and Cementon (now known as Smith's Landing in honor of Rufus Smith, who arrived in the area in 1813 and was involved in the development of the town). It is the fourth largest producer of cement in the nation and is currently owned by a German company.

Cement has long been a part of the Hudson River Valley; its plants once employed thousands, and landmarks like the base of the Statue of Liberty and the Brooklyn Bridge were made from cement floated down the river on barges. One Greene County hamlet, Cementon, was even named after the industry.

Interestingly, in 2001 the Town of Catskill voted to change the name back to Smith's Landing, the name it had before the late nineteenth century brought the area its first cement plant. Cement production didn't disappear with the name change. Why locate there? Limestone is plentiful in the ground. Through heating in high-temperature kilns it is processed into cement, the main ingredient of concrete. The Hudson River location is perfect for barges to move the finished product. And there is proximity to the enormous Northeast market.

Despite the opposition of environmental, community, and preservation groups, who have won the battle to prevent expansion of these facilities in recent years, cement is still a presence. The Hudson River's scenic beauty and its commercial aspects must continue to coexist. Meanwhile, industry on the Hudson continues, in Smith's Landing and elsewhere. Industrial plants may not be expanding, but they are a part of the riverfront mosaic.

The Whip, Historic Ice Boat on the Hudson

Tivoli—Iceboating

Many of the wealthy Hudson River families—the Roosevelts, Rogerses, and Grinnells—sailed and raced large elegant wooden ice yachts. The sport continues today with clubs of dedicated sailors who have lovingly restored, maintained, and continue to sail the antique ice yachts of yesteryear. The sport developed in Dutchess County in the mid-nineteenth century, and for a time that area was the undisputed center of iceboating in the world.

Even these days, January on the Hudson River brings out enthusiasts, watching the iceboats slide along the river with lightning speed—80 to 100 mph on clear stretches of smooth ice. Iceboats are lean and spare. A vertical sail rises from a horizontal cross-shaped frame running on three skates. A rudder handle turns the rear skate for steering. The boats move faster than the winds that propel them. In 1869 one of the largest ice yachts was built for racing on the frozen Hudson; it was called the *Icicle.* Occasionally, it raced the railroad that ran alongside the Hudson.

Iceboats are not produced commercially to any great extent, but remain the province of hobbyists who

build them with high-quality wood and plywood as well as foam and fiberglass. There are no government licensing or registration requirements, but classes are offered through local clubs. Protective apparel is a must—windproof suit, helmet, and goggles. Safe conditions can change quickly with variations in light, temperature, and wind. Newcomers to the sport should consult experienced "hard-water" sailors through the Hudson River Ice Yacht Club for advice before venturing out!

Saugerties—Early History

In 1677 the Governor of New England, Sir Edmund Andros, purchased the land that became the village of Saugerties from Kaelcop, the chief of the local Esopus Indian tribe. The price was a piece of cloth, a blanket, a loaf of bread, and a shirt. The unusual name of Saugerties is derived from the Dutch for "sawyer," someone who operates a sawmill. The town has over eight miles of Hudson River shoreline, making it an attractive location for commerce. Over the centuries, brick, bluestone, paper, lead, iron, ice, and farm products all figured prominently in the history of the Saugerties, according to village historian, Marjorie Fallows Block, who provides a detailed account of these industries in her excellent book, *Saugerties* (Arcadia Publishing, 2010).

In the seventeenth century, the major business in the area was farming. Mills were important to refine the lumber cut down from acres of land being cleared for planting. The Terwilliger Mill, next to Seamon Park, operated as a gristmill until 1910. Several other sawmills and gristmills grew up along the local streams and Esopus Creek.

In 1828, Henry Barclay (who became the first president of the village) established the Ulster Iron Works and a paper mill. Both the "puddling" process (workers stirred molten iron with paddles to separate the metal from impurities) for making iron and the first Fourdrinier wire-web papermaking machine were introduced to America in Saugerties. Barclay purchased land and secured water privileges along the creek for the iron works. He had a dam erected and cut through several hundred feet of rock to provide waterpower for the production process until the business closed in 1888.

In the early nineteenth century bluestone was quarried commercially for the first time in the area now known as Veteran, a powder mill was built on Fish Creek, and a paint factory was opened on the Esopus. (Today travelers may notice signs for Barclay Heights, Fish Creek Road, and Powder Mill Road when passing through Saugerties.)

Industry led to a growth in population: the village reached 4,000 people by 1870 and remained the same for nearly a century. The manufacture of paper, white lead, paint, and shipment of hides and bluestone supported the area. Approximately 2,500 men worked

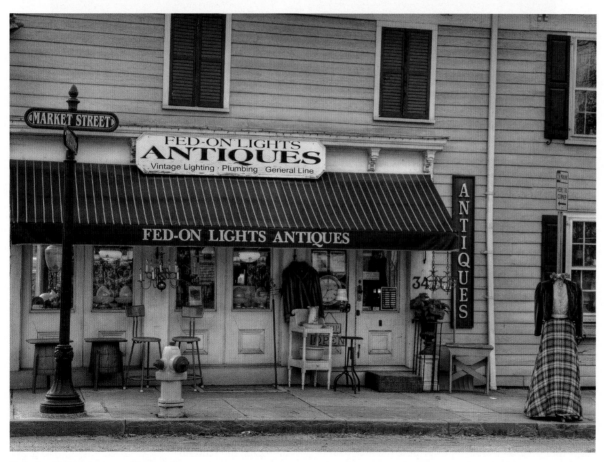

Fed-On Lights Antiques, Saugerties

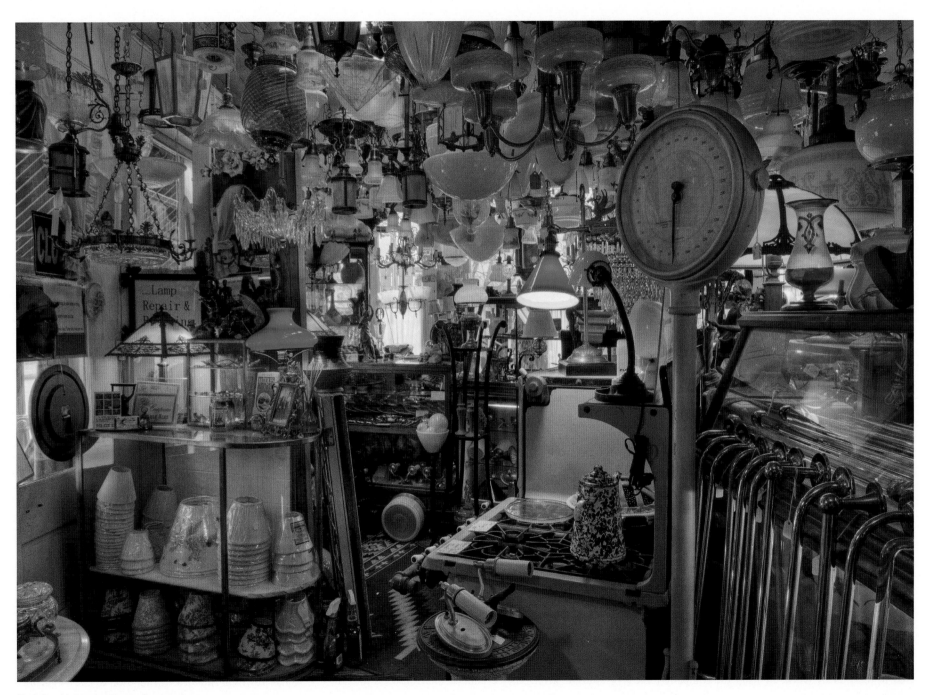

Fed-On Lights Antiques, Saugerties

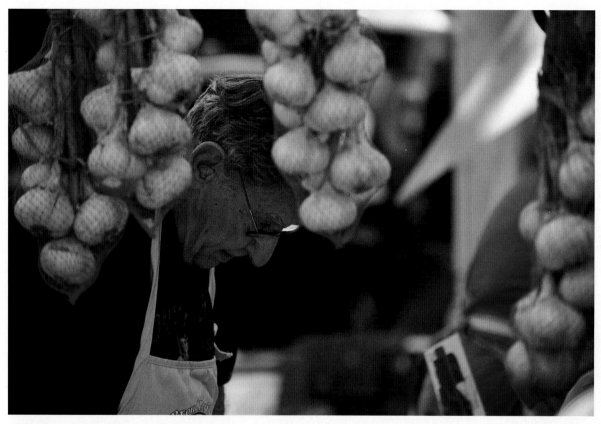

Garlic Festival, Saugerties

invited the Knausts to use his 35-acre cave for growing mushrooms. An ideal environment, the company "mushroomed" and became the largest such industry in the world with nearly fifteen million pounds grown annually.

Entertainment in nineteenth-century Saugerties, as in most towns, revolved around the community. The Orpheum Theater, built by J. C. Dawes in 1890, was a center for vaudeville acts and movies. The Opera House on Main Street, now the site of a bank, offered stage productions and classical performances. Public dances were held at the Seamon Building, now the Saugerties Furniture Mart.

Market Street Antique Shops—Saugerties Today

Once a prosperous river town, a center of the bluestone and tanning industries, Saugerties has had its ups and downs and today is home to approximately 20,000. In the 1980s and 1990s the town developed into an antique center. Dealers and auctioneers still regularly visit the stores in town. One of these shops, Fed-On Lights Antiques, is a two-story, 3,000-square-foot emporium chock-full of vintage lighting and plumbing fixtures and architectural elements. There are also antiques of all kinds, and the offerings will keep collectors busy for hours combing through this treasure trove of eclectic items.

Many of the antique shops have given way to restaurants and boutiques, but despite the changes, Saugerties has retained its Main Street and sense of community into the twenty-first century. The heart of the village has been designated a National Historic District, and in 2009 Arthur Frommer's *Budget Travel Magazine* named Saugerties one of its "Top 10 Coolest Small Towns in America." In addition to *Late Night* host Jimmy Fallon, notable natives include Congressman

quarrying and shipping about 1.5 million dollars worth of bluestone each year from Glasco, Malden, and Saugerties. It was shipped down the Hudson River to be used on the sidewalks of New York City.

The Martin Cantine Paper Company in Saugerties perfected the manufacturing of coated paper. This fine product became known as the "Tiffany of the Paper Trade." Raw-stock paper would arrive at the train depot and be driven to the mill by chain drive truck. The coal, lumber, and clay used in the coating process arrived by boats on the Esopus Creek and were delivered to the mill by truck. In 1903 the company took over the Ulster Iron Works property and the Cantine

Company became a major industry in the county. They made cartons for Old Gold cigarettes, and business boomed in the post–World War II era. After the mid-1950s the Hudson was no longer an efficient means of transportation and the required pollution control equipment drained the company's funds, finally ceasing operations in the late 1970s.

The "tray method" of growing mushrooms was developed and patented by Herman and Henry Knaust of Saugerties around 1940. These brothers began growing mushrooms in the abandoned icehouses along the Hudson River. They expanded their business into the caves in Rosendale thanks to Andrew Snyder, who

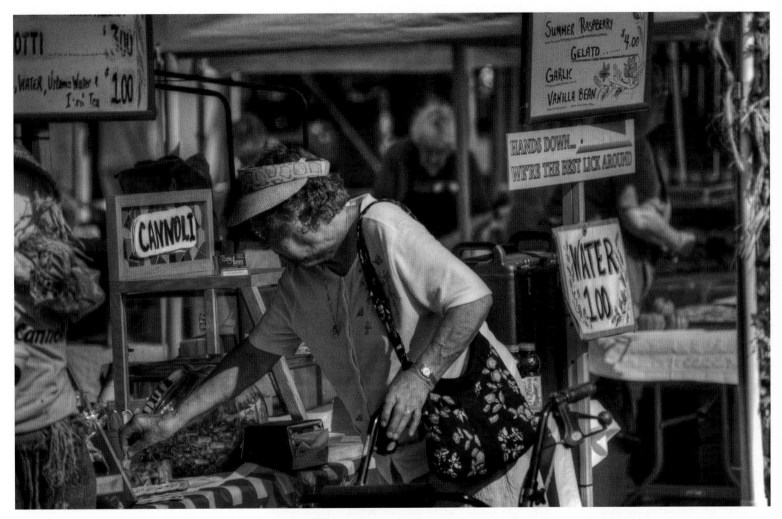

Browsing at the Garlic Festival in Saugerties

Maurice Hinchey, baseball historian John Thorn, herbalist Susun Weed, and John Henson, son of the late Muppets creator Jim Henson.

Every September since 1988 the town of Saugerties hosts the Garlic Festival at the Cantine Field Recreation Complex. Attendance often reaches 40,000 and the celebration offers an array of fabulous and unusual garlic-laden creations including garlic chicken, garlic soup, garlic ice cream, and garlic chocolates. There is continual live entertainment and vendors sell amazingly arcane varieties of garlic to festival attendees.

Another renowned annual event in Saugerties revolves around a flower—the chrysanthemum. Every year in October the Mum Festival is held in Seamon Park, a lovely place that is transformed into a floral panorama for the occasion.

Saugerties has made its mark on the Hudson Valley art scene. Since 2003 the Saugerties Artists Studio Tour, held on a weekend in August, offers free, self-guided visits to the home studios of 40 working artists. Anyone can obtain a map from the website and enjoy demonstrations of stone carving, printmaking, welding, or kiln firing, with artwork on sale at reasonable prices.

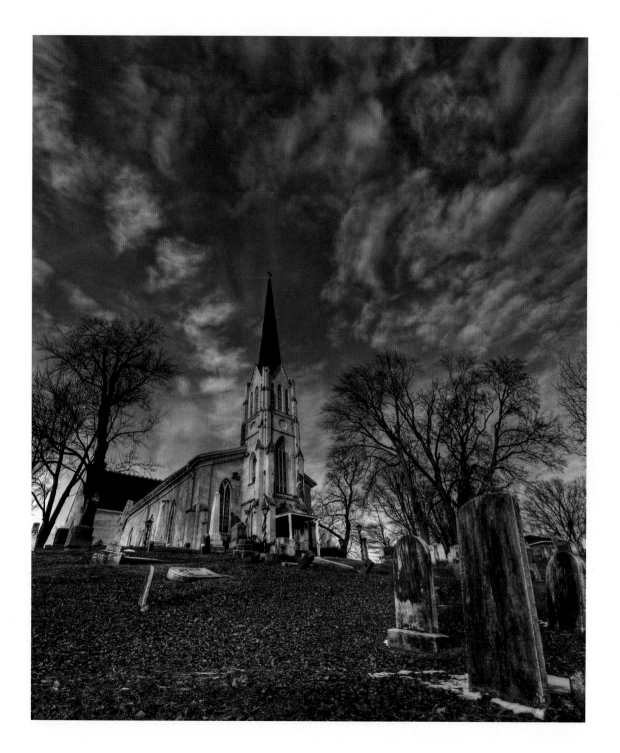

During the summer of 1994 the town of Saugerties made national headlines when it hosted the three-day Woodstock '94 Festival celebrating the 25-year anniversary of the legendary event held in Bethel, New York during August 1969.

St. Mary of the Snow

Known as "the Parish of the Hudson," St. Mary of the Snow was the only Catholic parish between New York City and Albany when it was built in 1833. With its beautiful name and picture-postcard appearance, this classic country church features a high steeple, traditional stained glass windows, and a cemetery that dates back to the mid-nineteenth century. The stark simplicity of the church is its most striking feature. A closer look reveals a Tiffany stained glass window depicting the Virgin Mary at the Assumption.

Late Night host Jimmy Fallon, who grew up in Saugerties, attended elementary school at St. Mary of the Snow.

Saugerties Light on Ice

The spectacle of light on ice in the Hudson River is magnificent to behold. Although these days most people think of this ice as a nuisance, something to be cleared out of the way, there was a time when ice meant business. The location of Saugerties on the Hudson made the town an ideal place to harvest ice from the river during most of the nineteenth century into the early twentieth century. Icehouses were located in the surrounding hamlets of Glasco and Malden; those in the entire Hudson Valley stored nearly three

St. Mary of the Snow Church, Saugerties

38

million tons of ice during the winter season. In fact, ice from the Hudson River was shipped to countries as far away as India.

A *New York Times* article dated January 20, 1904, provides some anecdotal evidence of climate change. It was entitled "Fatal Results of Cold Wave—Hudson River Towns Hard Hit—Ice Harvesters Quit Work." "Cold which exceeds that of several weeks ago is being experienced all along the Hudson today and in many riverside towns schools have closed and business has come to a standstill. Many cases of severe frostbite have been reported. The average temperature in Poughkeepsie today was 22 degrees below zero. At Catskill the intense cold has caused thousands of the ice harvesters to quit the river and return to their homes."

Krause's Chocolates

A landmark on South Partition Street near the Esopus Creek is Krause's Chocolates. The Krause family has been in the candy business since 1929.

Grandfather Alfred Krause apprenticed as a candy maker in Germany before immigrating to America and opening a store in Wyandanch, Long Island. His son, Manfred, opened the Saugerties store in 1972, and grandson Karl took over in 2001. Current owner Karl Krause may be a third-generation confectioner, but he still uses his grandfather's recipes (closely guarded secrets) and hand-dipping techniques. In fact, during the holiday season, five dippers work twelve-hour days dipping one chocolate at a time, a highly unusual practice in the twenty-first century.

Krause's is a charming, lively shop where the delicious fragrance of chocolate overwhelms visitors

Showroom, Krause's Chocolates, Saugerties

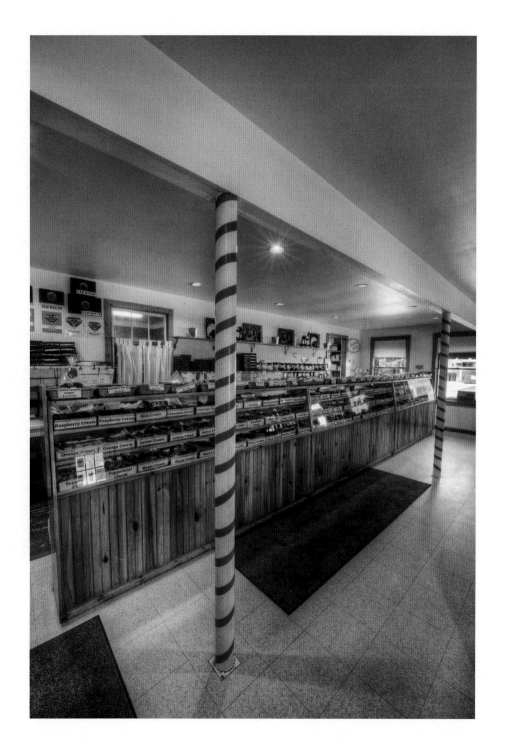

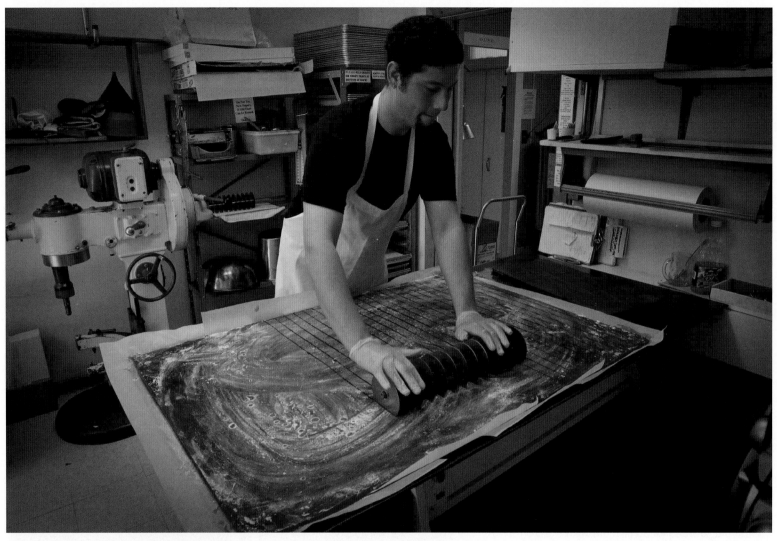

Chris Jackwoods cutting raspberry squares, Krause's Chocolates, Saugerties

upon entering. There are over 50 varieties of premium chocolates, homemade fudge, and peanut brittle—all handmade daily with fresh ingredients (many organic). Many Saugertesians who move away still crave their local chocolate and thanks to the Internet are able to easily obtain it!

Catskill Animal Sanctuary

Since 2003, Catskill Animal Sanctuary, an 80-acre complex of barns, paddocks, shelters, and pastureland, has provided a home for over 1,700 abused and abandoned horses and farm animals. Part of the mission

of CAS is to raise public awareness about the realities of factory farms and the impact agribusiness has had on the lives of all Americans. They offer a variety of innovative workshops, a range of school programs, and tours of the property for visitors. Recently the sanctuary has undergone a conversion to solar energy and

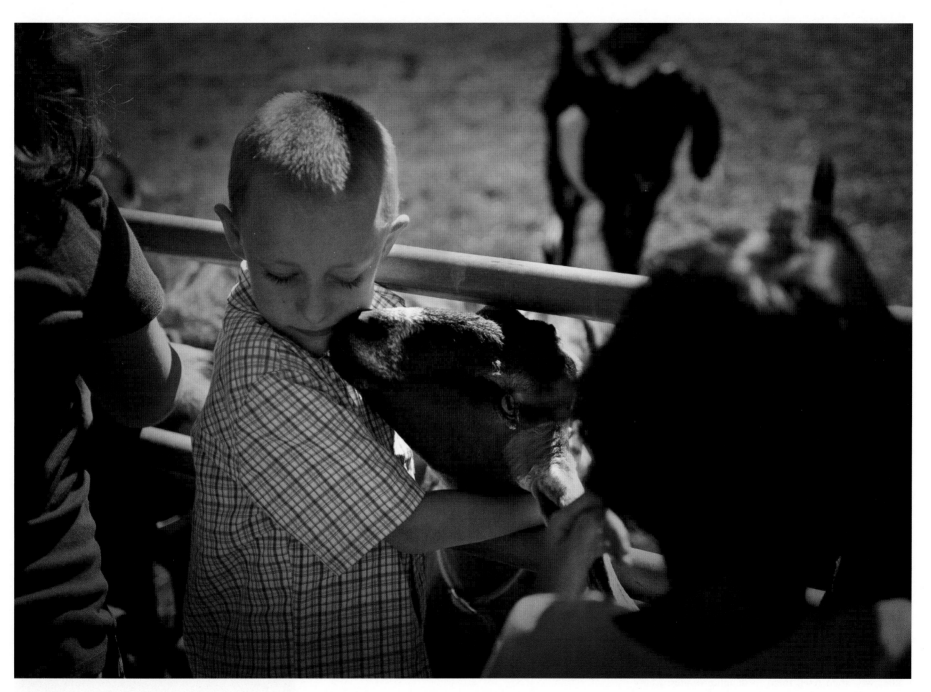

Love at Catskill Animal Sanctuary, Saugerties

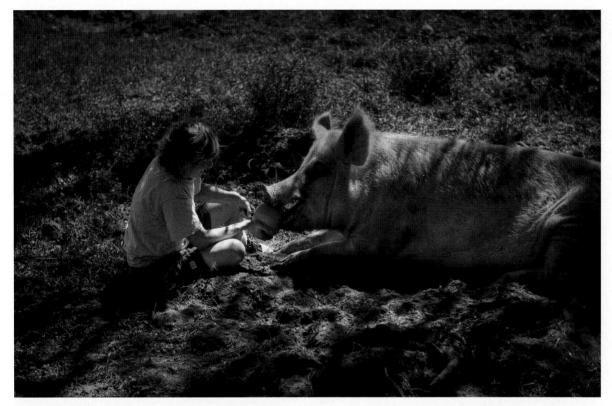

Kathy Stevens and Franklin, Catskill Animal Sanctuary, Saugerties

The Esopus Creek, a small stream, is a tributary of the Hudson that joins the river by the village of Saugerties. (The word "Esopus" is a Europeanized form of an Algonkian word for a brook.) It is renowned by fishing enthusiasts who catch trout, bass, pike, carp, pickerel, and perch here. The Esopus Creek is particularly accessible and just about anyone can get to the best fishing spots; a license is necessary but easy to obtain.

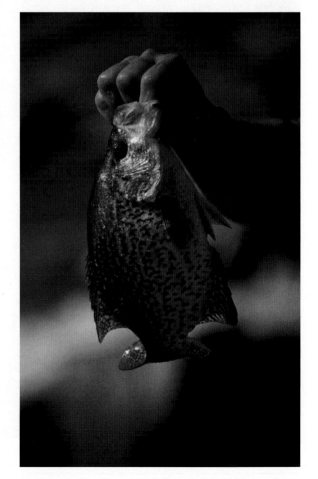

is now 100 percent solar powered. Before embarking on this venture in Saugerties, founder Kathy Stevens spent months doing research and traveling to sanctuaries across America.

Where do the animals come from? CAS has taken in abused animals from factory farms. They rescued boxes of chicks left in dumpsters after classroom egg-hatching projects. Others saved include draft horses worn out from a lifetime of pulling carriages filled with tourists or wagons loaded with trees. After decades of service such animals are usually sent to auction to be bid on by horse-traders who then resell them to slaughterhouses. Many in residence have been victims of chronic starvation;

often their owners could no longer afford to feed and care for them properly.

CAS takes in animals when they are fighting for their lives. Those who work there feel it's a gift to be able to fight alongside them by providing proper nourishment, comfortable shelter, and expert medical care. Kathy Stevens considers herself lucky to observe the transformation from broken spirited to lively creatures, the reason she feels so passionately about her work. "We get to say with every word, gesture, and action, 'you're safe here'; that's the greatest joy of this work."

Catch of the day

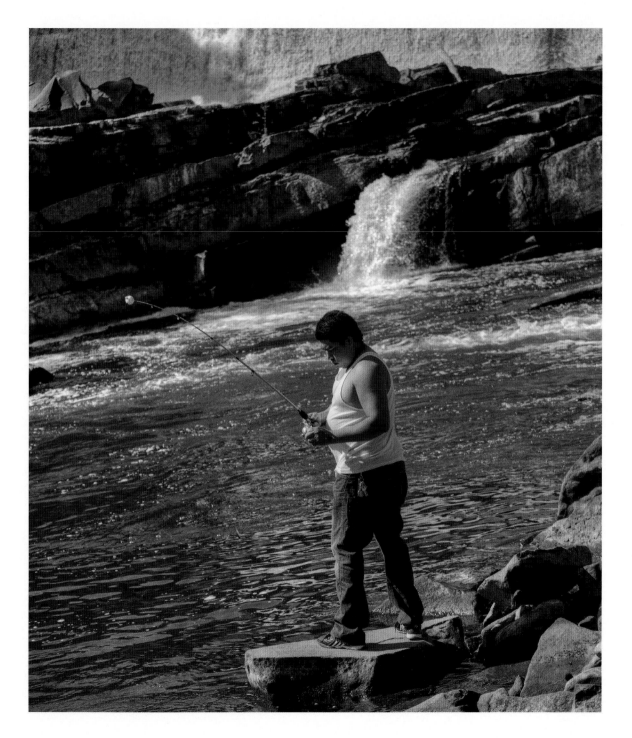

Fisherman, Esopus Creek Dam

The Clearwater *in Dry Dock*

During the winter months, the 106-foot-long sloop *Clearwater* is docked at Lynch's Marina in Saugerties for maintenance and repair work. In sailing season, May through October, the majestic boat may be seen making its way up and down the Hudson. Occasionally, the mainsail needs to be replaced or the deck needs to be replanked. Rot is the worst enemy of wood and can turn it into a soggy sponge.

Clearwater's story began in 1966 when a handful of Hudson Valley residents came together believing that by learning to care for one boat on one river, the public would become concerned about protecting all our waterways from pollution. It was decided the best boat for the job was a replica of a vessel that once sailed the Hudson—a Dutch sloop of the eighteenth and nineteenth centuries.

The sloop *Clearwater* was launched in 1969. For over 40 years, it has traveled to towns and cities along the river offering environmental education programs. It was specially designed to withstand the variable winds, currents, and depths of the Hudson. *Clearwater* is a vital link between towns. Instead of carrying food, mail, and supplies, as she would have in centuries long gone, she carries a message. To those who see her broad sails she is a reminder of the beauty and wealth of our region's waterways and the urgency of keeping them pristine and accessible. The mission of the *Clearwater* is to educate the public about the importance of preservation of the Hudson River and its tributaries. Pete Seeger, folksinger and conservationist, was in the forefront of this widespread educational movement. Thanks to his efforts as well as those of a small group of committed citizens, the

Clearwater takes nearly 13,000 people sailing to teach environmental science, navigation, and local history on the Hudson River every year.

In 2010 the iconic sloop added a mobile environmental monitoring system that enables scientists to "take the pulse" of the Hudson River. This installation is part of a monitoring network composed of eight permanent stations along the river between the Albany area and Manhattan. This development will make a great deal of information about the river accessible to classrooms via the Internet, enabling students to learn more about the history, ecology, and culture of the Hudson Valley.

Clearwater repairs

Clearwater in dry dock for repairs

Saugerties Lighthouse

Lighthouses capture the imagination in ways few places can. There is something alluring about these solitary sentinels of the night. They hark back to an era when nautical travel reigned supreme and time moved more slowly. And as special as these buildings are, even more unusual is being able to stay overnight in one, as you can do at the Saugerties Lighthouse with its two cozy, sparsely furnished guest rooms.

This red brick restored lighthouse built in 1869 is the only Hudson Valley lighthouse with an operating bed & breakfast. Another unique feature is the half-mile nature trail visitors must walk (and at low tide) to reach it (unless they arrive by boat). Automation in 1954 made lighthouse keepers obsolete, and the building fell into disrepair. In 1978 local historian Ruth Reynolds Glunt and architect Elise Barry placed the lighthouse on the National Register. This led to the formation of the Saugerties Lighthouse Conservancy in 1985. After 36 years without a light in the tower, it was restored to operation in 1990; the Coast Guard installed a Fresnel lens with solar-powered light. There is a one-room museum in the lighthouse with displays of artifacts from the commercial heyday of Saugerties, a leading producer of bluestone during the nineteenth century. Interestingly, the tradition of lighthouse keeper has been revived since 1991; in fact, he serves a hearty breakfast in the morning to overnight guests.

Clearwater

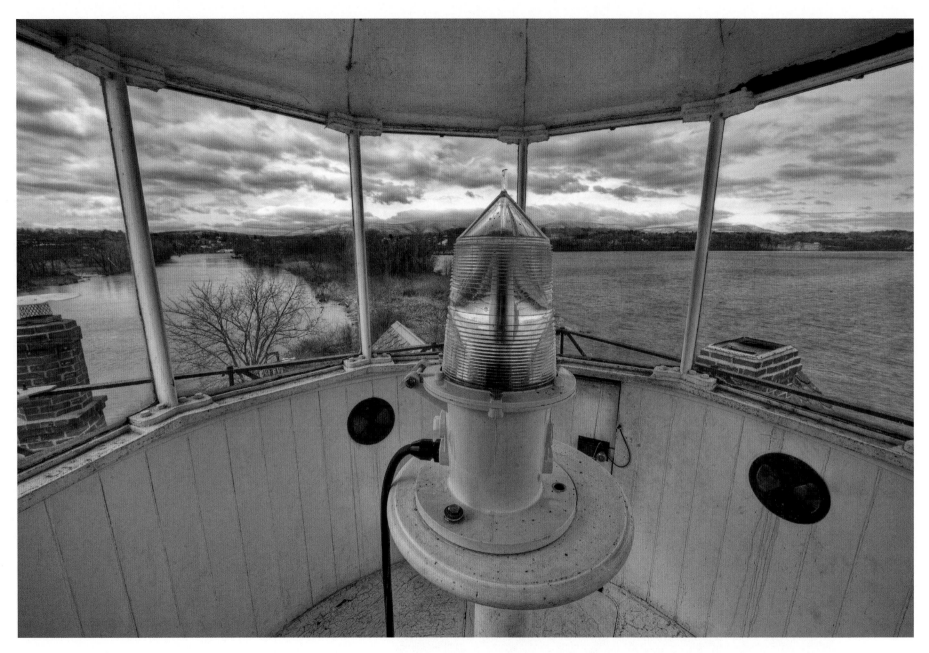

Saugerties Lighthouse Fresnel lens

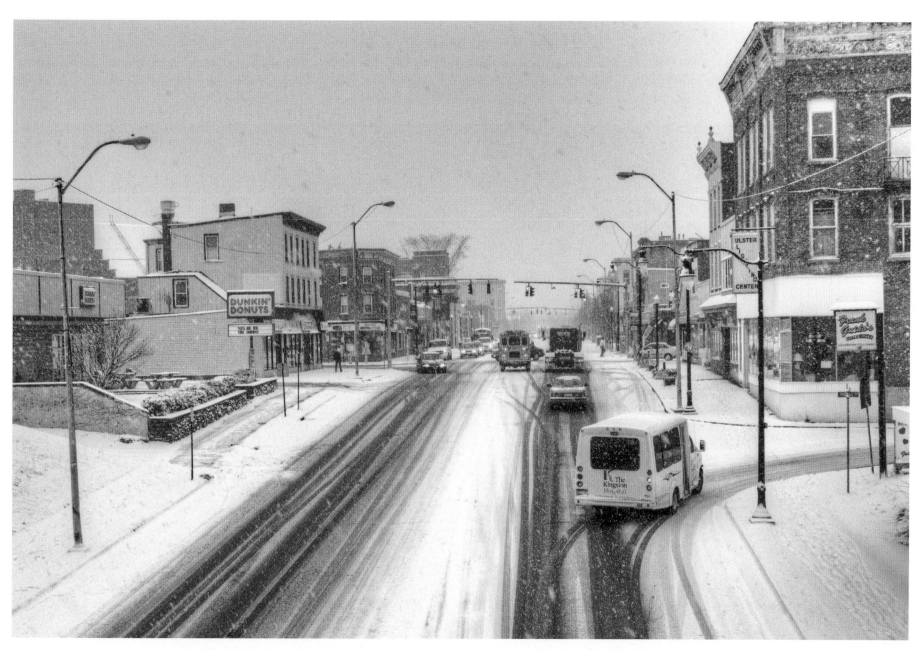

Snowstorm on Broadway, Kingston

Healing Circle Arbor, the Strand

A project sponsored by the Tobacco Free Coalition of Ulster County, the Healing Circle Arbor is a collaborative creation of people whose lives have been touched by cancer. Interestingly, the dome has become a place for contemplation in the busy Strand area of Kingston and intrigues travelers as well as local residents. The design motif is simulated stained glass windows and healing mandalas. (*Mandala* means circle in Sanskrit; mandala art refers to symbols painted in a circular frame.) The art embodies expressions of illumination, hope, and faith in the face of illness, uncertainty, and death. Every few years the artwork will change as the arbor is maintained and renewed.

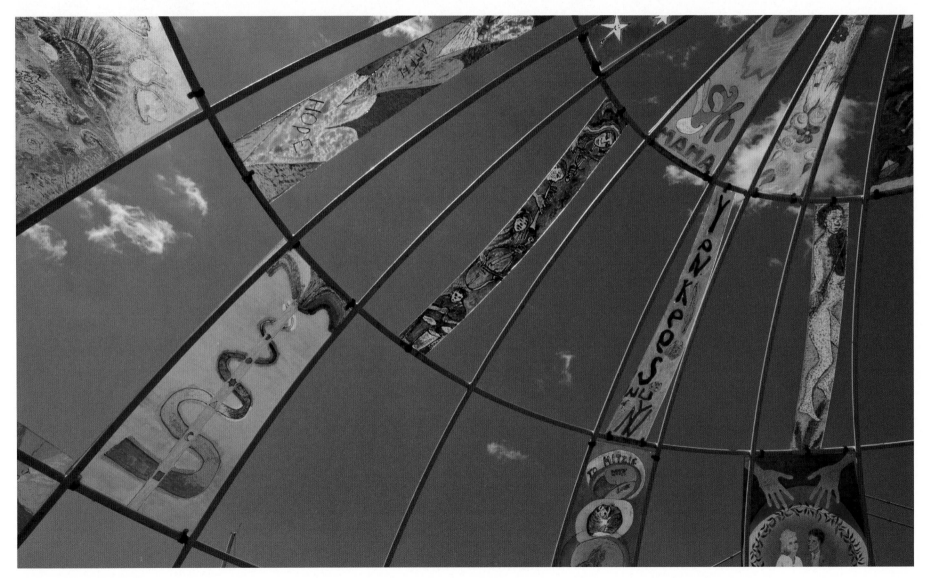

Healing Arbor, The Strand, Kingston, above

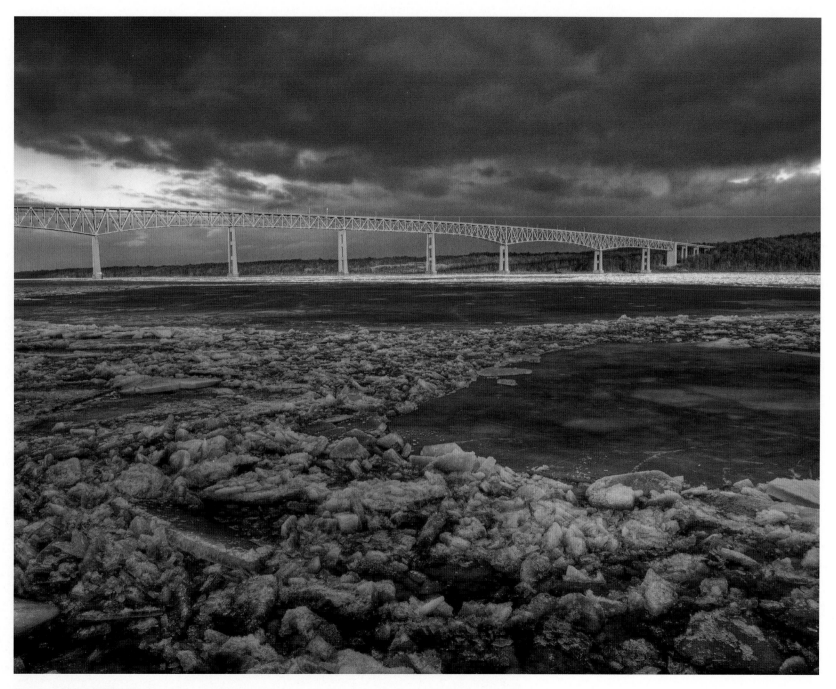

Kingston-Rhinecliff Bridge

Ice Floes / Kingston-Rhinecliff Bridge

The Kingston-Rhinecliff Bridge offers drivers an excellent vantage point to see the next weather system arriving . . . if they are looking to the north and south. The urge to look downward is irresistible. The giant jigsaw puzzle of ice pieces is compelling. Usually, by January, ice has settled in on much of the mid and upper Hudson River. Tidal currents eventually break up the solid ice into large floes that slowly make their way downstream. The ice itself is fascinating to watch and listen to—creaking, cracking against the endless push of the water. The floes scour the river's edges and everything along the shoreline. If you are able to get close to the river bank when the tide changes, you may actually see inshore ice flowing in one direction and the ice in the middle of the river going in the opposite direction.

Broadway Joe's

This neighborhood bar on Broadway in Kingston provides some 1950s kitsch to the neighborhood with its rooftop statues of Elvis and Marilyn Monroe singing. There is continual speculation as to who that other statue might be. It's the one lying down (it fell over). Out of curiosity I called the owner of Broadway Joe's. "It's one of the Blues Brothers—either Dan Ackroyd or John Belushi," he said, explaining that the other one of them was "somewhere in the basement" of the restaurant.

Brickyard factory ruins, above right

Sailing off Kingston Point, Hudson River, below right

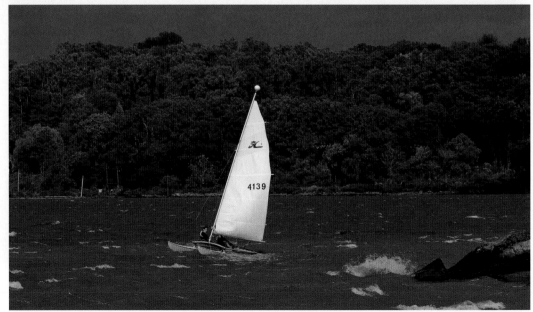

50

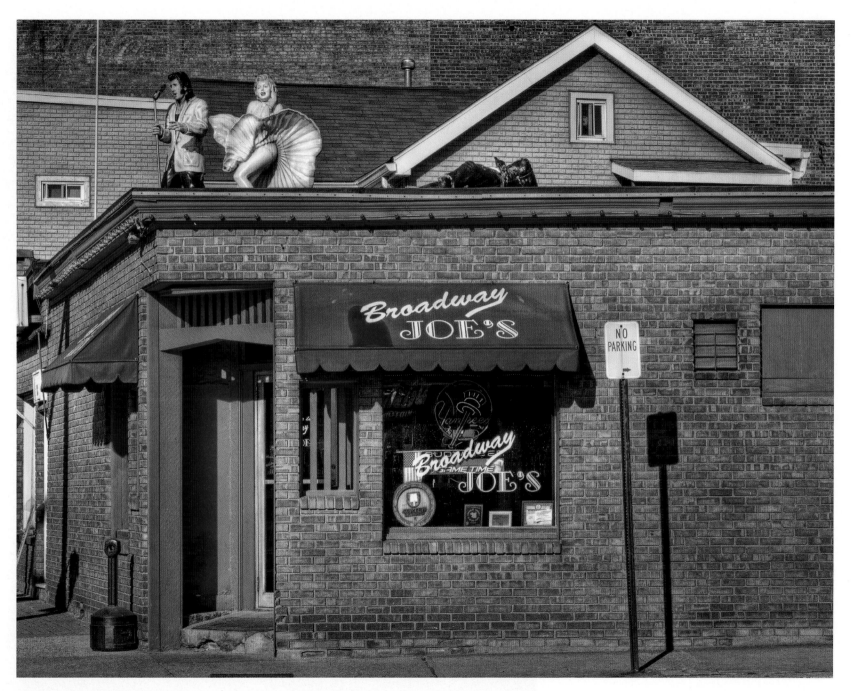

Broadway Joe's, Kingston

Abandoned Train Route 209—the Rondout

The name Rondout originated since this location was where a "redout," a fortified enclosed defensive area, was constructed which gave its name to the creek. At one time, the Rondout was the most important port between New York City and Albany. However, once the Depression of the 1930s set in, the area and its industries—coal transport, limestone mining, and bluestone—all declined. There was an upsurge in activity during the World War II years, especially in boat building, which continued to prosper through the 1950s. After that, the downward trend continued and with the industry gone, residents and businesses left the Rondout area. In the late 1960s a federal program called Urban Renewal destroyed several buildings in the downtown Rondout in an effort to clear rundown sections and build a state highway through the area. The program was a failure and added further to the deterioration of the neighborhood. Finally, in the 1980s restaurants, shops, and the Hudson River Maritime Museum arrived and the Rondout started on the path to revitalization, gradually becoming the popular tourist destination it is today.

Occasionally, remnants of bygone times, like the abandoned train on the side of the highway, are reminders of the ups and downs in the area's volatile history over the past century.

Kingston Riverport

A partnership between the Hudson River sloop *Clearwater* and the Hudson River Maritime Museum

Abandoned train, Kingston, right

Wurts Street Bridge connects Kingston and Port Ewen, far right

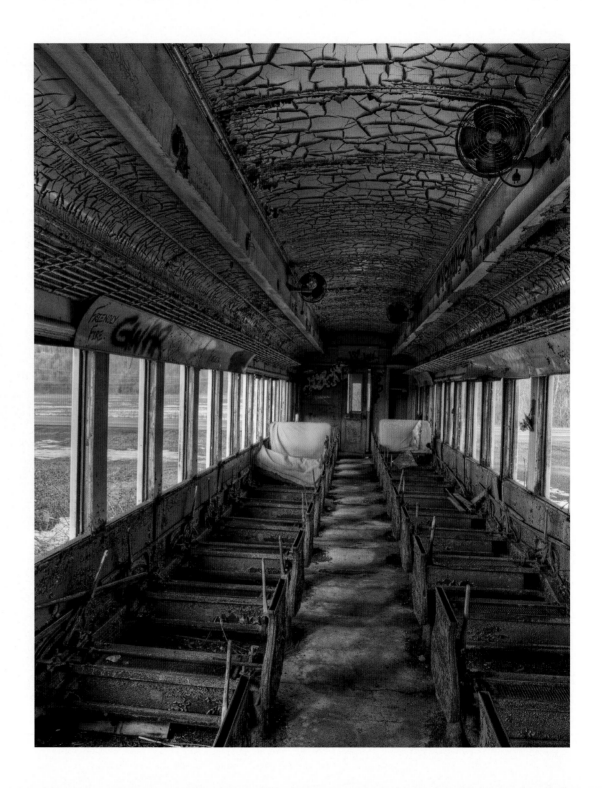

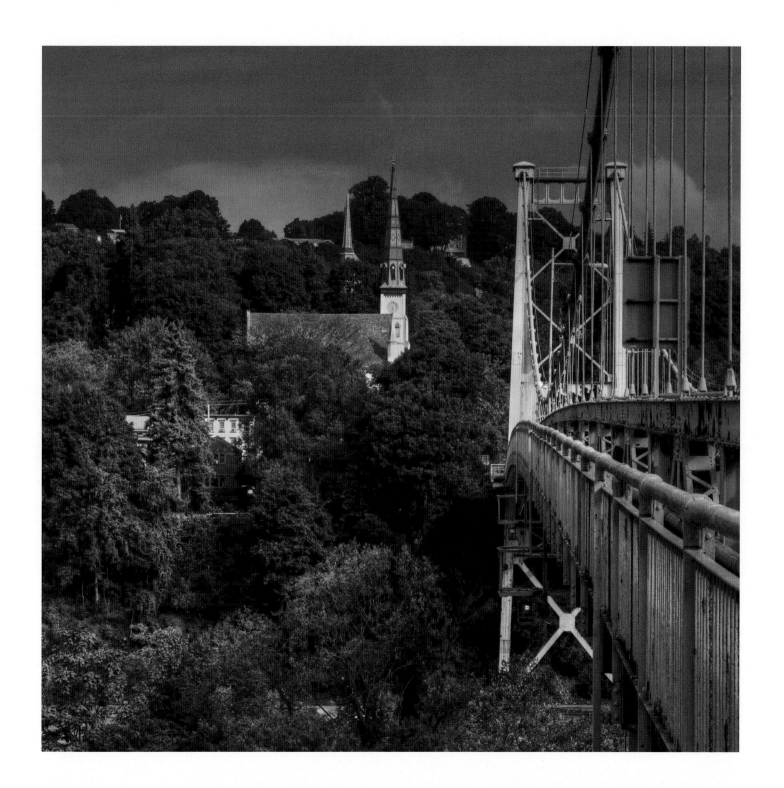

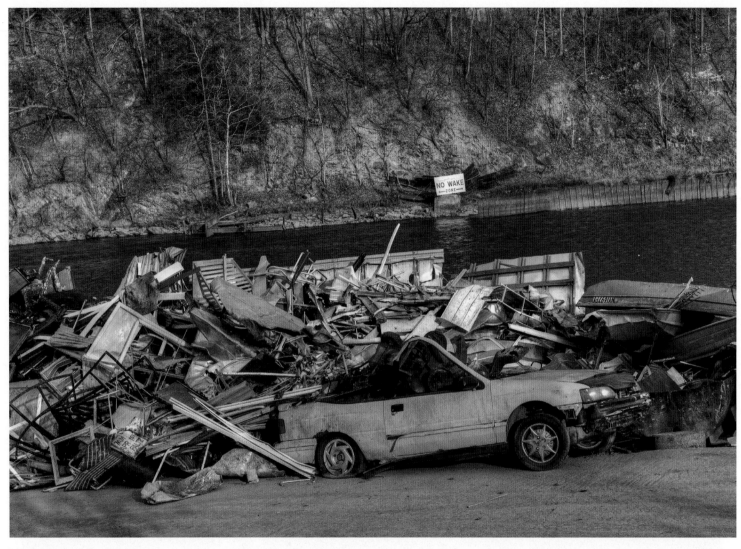

West Kingston Recycling

was formed in 2010 to establish the Rondout Creek in Kingston as the sloop *Clearwater*'s homeport. Both organizations will work to create Kingston Riverport with the goal of improving visitor and education facilities, developing boat repair capabilities and a boat-building shop, and expanding the museum's schedule so that it is open year-round. The *Clearwater* would dock in Kingston during the winter months, rather than in Saugerties, and have crew support facilities there as well.

The Hudson River Maritime Museum was founded in 1980 and is the only museum in New York State dedicated to preserving the maritime history of the Hudson River. The *Clearwater* belongs to the entire river and has a rather nomadic existence. The two educational organizations complement one another and their collaboration will be a boon to both.

Rondout Lighthouse, right

54

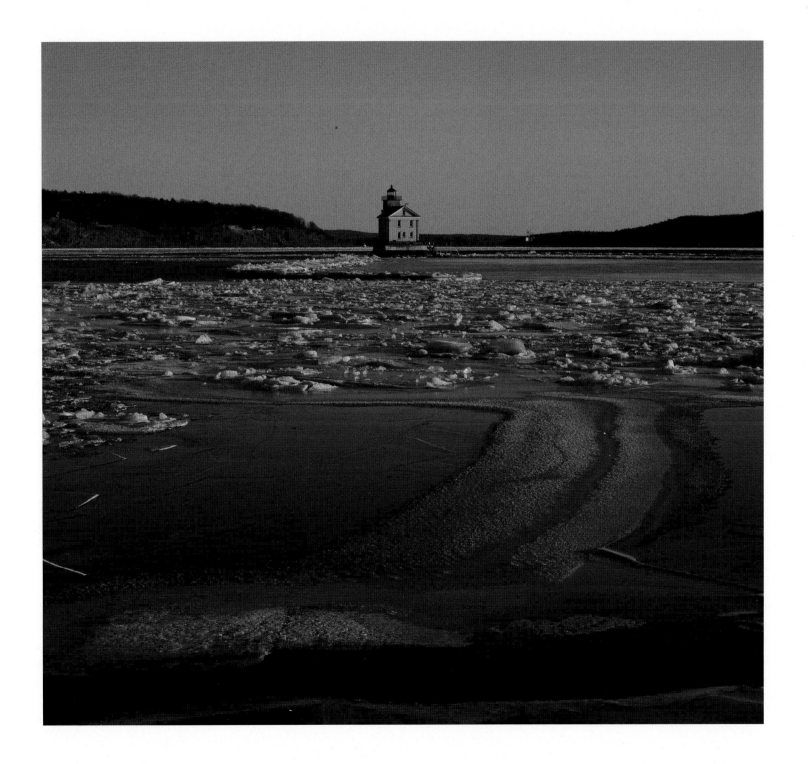

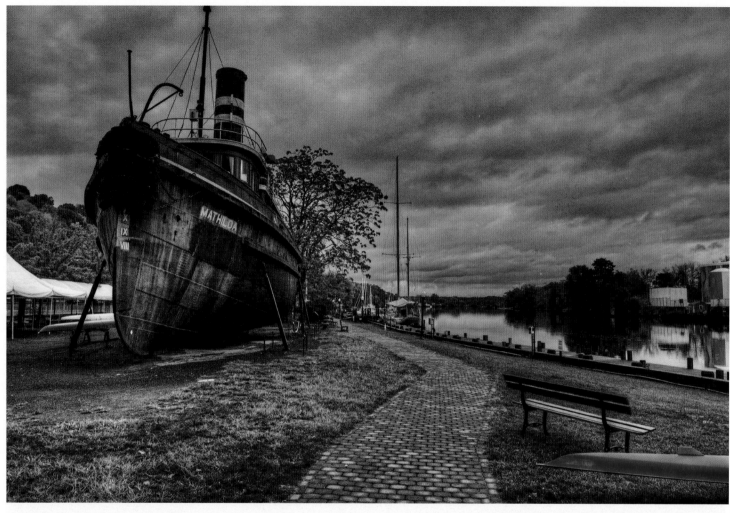

Mathilda, Hudson River Maritime Museum

George Clinton Statue, Academy Green Park

George Clinton (1739–1812) and Henry Hudson (1570–1611) are striking bronze figures gracing Academy Park in Kingston. It is fitting these historic figures are memorialized in the first capital of New York State. The story of how the statues arrived in the park is

an unusual one. The sculptures by John Massey Rhind (1860–1936) first appeared on the Corn Exchange Bank building façade at 52 Broadway in Manhattan cast by the foundry Gorham Manufacturing in 1898. There was a third statue as well, Peter Stuyvesant (1612–1672). The three eleven-foot bronzes were removed and sent to the Brooklyn junkyard when the

Corn Exchange was remodeled. The fate of the statues was publicized in a *New York Times* article in 1943. One reader, Emily Crane Chadbourne, rescued the three sculptures: Peter Stuyvesant ended up in Canada, but George Clinton and Henry Hudson were given to Ulster County. With the help of landscape architect Alfred Geiffert, new bases were created and the statues

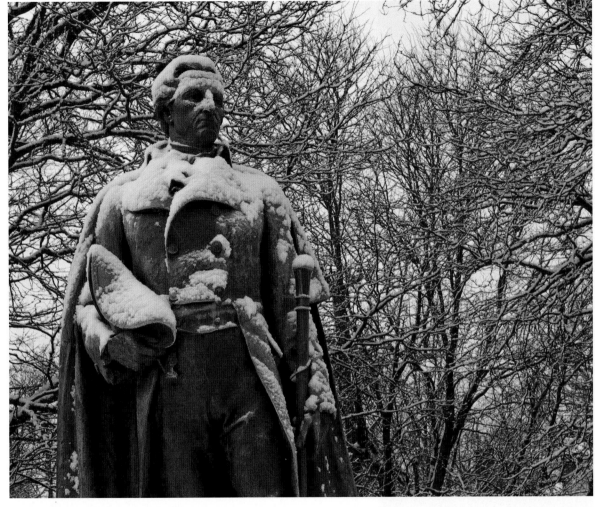

George Clinton statue, Academy Green, Kingston

and four years later was vice president under James Madison. He died in 1812 in Washington, D.C. from pneumonia and was buried in Congressional Cemetery. However, in 1908, a committee in Kingston formed and brought his body and monument back to the Old Dutch Church Cemetery there.

Old Dutch Church

Organized in 1659, the Reformed Protestant Dutch Church of Kingston has served the people of the area since then, and is one of the oldest continually existing congregations in America. A National Historic Landmark, the current building was constructed in 1852; Minard Lafever was the architect. The bluestone exterior is Renaissance Revival style and the windows were made in the Tiffany studios. Local tradition once held that the bell was cast from silver and copper items donated by members of the congregation when a child was baptized. The gravestones in the surrounding churchyard date back hundreds of years. From the time of its founding in the seventeenth century, meticulous baptism and marriage records have been kept here, a welcome treasure for both historians and genealogists. The church maintains a museum that houses these records and other artifacts. During the Revolutionary War, George Washington paid a visit due to the church's strong support of the patriot cause. He wrote a thank you note that is on exhibit in the church. With a 225-foot steeple, the Old Dutch Church is the tallest building in Kingston and has become a symbol of the city as well as an anchor for the Uptown area.

were rededicated in June 1950 at the Academy Green on Albany Avenue.

Standing proud and poised, each colossal statue in traditional dress is portrayed with a flourish of garment and gesture. They are particularly interesting to gaze upon when lightly covered with freshly fallen snow.

Many New Yorkers are more familiar with Henry Hudson than George Clinton, who became the first governor of New York State on July 30, 1777, the same year Kingston became the first capital of the state. He served seven three-year terms, the longest serving governor in the state's history. In 1805 he went on to become vice president under Thomas Jefferson

Cash was in short supply in the Hudson Valley during much of the eighteenth century and exchanges or bartering of goods and services was common. Bookkeeping records were critical. Records of ledgers confirm the role rural merchants played as they facilitated

trade between local farmers and merchants in New York City. One of the local Kingston merchants during this era was Jean Cottin. In his will he left his accounting records to the Old Dutch Church intending that any income due would go to the poor in the community. In fact, several such ledgers are in the archives of the Old Dutch Church today and provide a record of the types of goods in demand. Cottin bought wheat from local farmers and pelts from trappers and then sold them to Manhattan merchants. In turn, he received imported items his customers wanted like china and fine cloth items. Interestingly, this economic system intertwined family life, trade, and the church.

Senate House Museum

The first New York State Senate met in this building in 1777 when it was the home of Abraham Van Gaasbeek. Built in 1676, it was burned by the British a century later and then reconstructed.

In 1777, the British considered Kingston a hotbed of disloyalty to King George III. The farmers in the area had given General George Washington's troops wheat and food supplies (hence the area later became known as "the breadbasket of the American Revolution").

John Jay and other patriots gathered at this stone building to establish the first New York State Senate. The first state assembly convened nearby and Kingston became the state's first capital. But a month after these meetings, General William Clinton brought British forces up the Hudson River to meet General Burgoyne. Landing at Kingston Point, they marched on the village intending to punish residents for their disloyalty to

Old Dutch Church, Kingston, left

Senate House Museum, Stockade District, Kingston, right

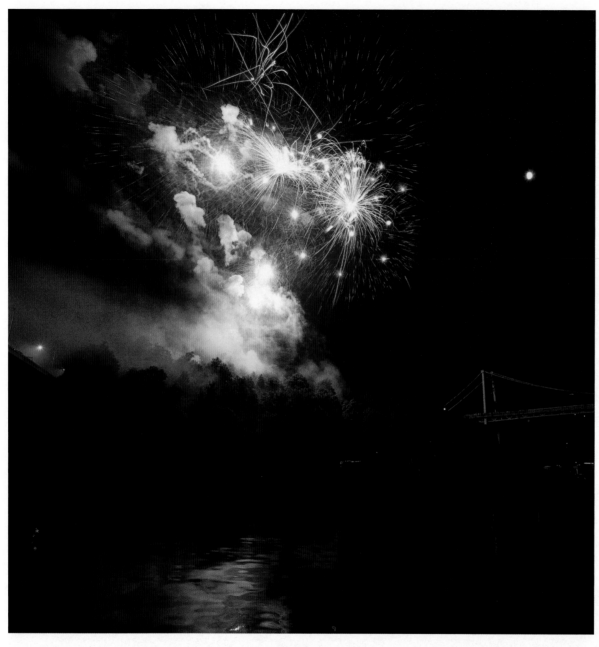

Fireworks at the Strand, Rondout Creek, Kingston

the Crown. They torched almost every house in the village, forcing residents to move to Hurley. Residents of Kingston returned and rebuilt their stone houses, including the one where the first senate met.

Descendants of the original builder, Wessel ten Broeck, occupied the residence until 1888 when they gave it to New York State. The adjacent museum, built in 1927, has the largest collection of painter John Vanderlyn's works in the country.

Kingston Fireworks

A tradition in the city of Kingston, the annual Independence Day fireworks are held the Sunday night before the Fourth of July at the Rondout waterfront. A source of delight and amazement, the fireworks are viewed by thousands who gather to watch the spectacular annual display.

Immanuel Evangelical Lutheran Church

Traveling south on Route 9W, the steeple of the Immanuel Evangelical Lutheran Church on Livingston Street is one of the prominent landmarks visible in the distance. The Rondout area of Kingston had numerous steeples piercing the skies as sanctuaries of all faiths were built during the mid-nineteenth century when the area was booming. This one is particularly picturesque, the sole steeple in the distance, a reminder of an era long gone.

Poughkeepsie History

Poughkeepsie derives its unusual name from the Algonkian, and it means "Reed Covered Lodge by the Little Water Place." The Dutch and English spelled the name phonetically—Pockkeepsin—which eventually became Poughkeepsie. The city, founded in 1683, became the second capital of New York State in 1788 after the British burned Kingston. Located at the juncture of critical transportation routes (the Albany Post Road and Hudson River), Poughkeepsie grew into a prosperous market during the eighteenth and nineteenth centuries. The city developed as a shipping and whale-rendering center, lumber- and grain-milling town, and later as an industrial city with a glass factory, paper mills, breweries, potteries, brickyards, carpet mills, and a reaper works.

Matthew Vassar (1792–1868), founder of Vassar College, arrived from England with his family in 1797 and settled on a farm in the city where his father began a successful beer brewing business. Interestingly, Matthew Vassar had no formal education but was a voracious reader and an astute businessperson. He inherited and expanded the family business but never married or had children. In 1861, inspired by his niece, Lydia Booth, Matthew decided to finance one of the first women's colleges in America. He presented the board of the school with a tin box containing half his fortune—$408,000 and a deed for two hundred acres of land. Matthew Vassar died in midsentence while giving an address at the annual board meeting of Vassar College in 1868; he is buried in Poughkeepsie Rural Cemetery.

Until 1972, Poughkeepsie was home of the Smith Brothers cough drop factory. William and Andrew Smith, the Smith Brothers, produced and packaged some of the first cough drops in the mid-nineteenth century. Their

Poughkeepsie train station

Garfield Place, Poughkeepsie

father came up with the formula and began making the candies on a small scale in the family's Poughkeepsie kitchen and selling them in the Hudson Valley. After being advertised in the local newspaper, the popularity of the cough drops burgeoned. The business expanded and moved to larger quarters. The Smiths' first factory-produced line of cough drops came from Poughkeepsie in 1872 and the business thrived there for a century. The Smith Brothers' gravesite is in the Poughkeepsie Rural Cemetery.

Poughkeepsie grew from an agricultural market town to a small city with a diversified economy and later an urban center dependent on IBM. The story is similar to other small cities in the Northeast with the exodus of Main Street businesses to malls in the outlying areas and suburbs followed by a steep decline. There are approximately two hundred buildings included in historic districts throughout the city, remnants of a prosperous era gone by. In recent years the waterfront area, revitalized Main Street, and the Walkway Over the Hudson have bolstered tourism to the city.

Historic Districts

The best way to explore the city of Poughkeepsie and its architectural treasures is on foot. Those who drive through are likely to miss many of the interesting enclaves, like the Mount Carmel Italian neighborhood renowned for its excellent pastry shops and cafes, close to the Walkway.

The Academy Street Historic District incorporates a range of architectural styles and has been listed on the National Register of Historic Places

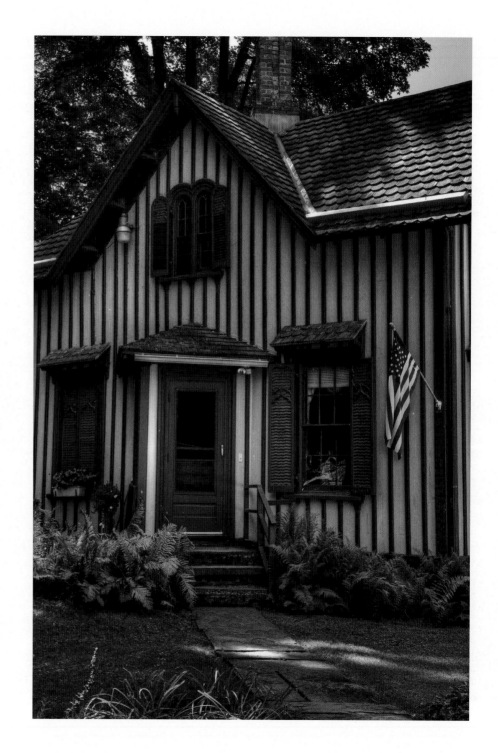

Porters Lodge, Springside, Poughkeepsie

since 1982. Academy Street is tree lined, with a large landscaped park around Christ Church at the north end and wooded lots at the south end. The street was the first planned neighborhood in Poughkeepsie and retains its mid-nineteenth century atmosphere. Among the architects who contributed buildings to the street are William J. Beardsley, Percival Lloyd, and William Appleton Potter.

While the Lower Mill Street and Union Street Historic districts were largely filled with homes of the working class, the Garfield Place Historic District was where the prosperous citizens of Poughkeepsie resided. Constructed on the summit of a hill during the mid-nineteenth century, the approximately 25 spacious homes here were where doctors, lawyers, merchants, and factory-owners lived. An advertisement dating from 1873 describes the area as "a quiet neighborhood with no fences, in full view of the Hudson River and within a ten minute walk from the post office." That description holds up today, and visitors to the city should make sure to walk through this majestic street that was added to the National Register of Historic Places in 1972.

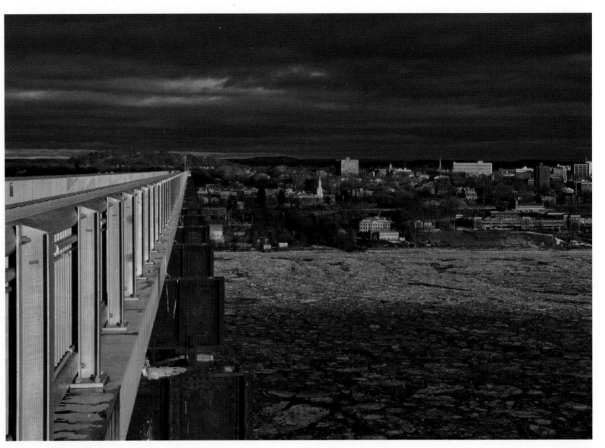
Walkway Over the Hudson

Springside

In the first half of the nineteenth century, the site known as Springside was part of the Allen farm in the city of Poughkeepsie. In 1850 Matthew Vassar purchased the property and hired Andrew Jackson Downing, America's foremost landscape designer, to develop the site as his country estate—part scenic gardens and part working farm. Vassar continued to improve Springside for the rest of his life, spending over $100,000 on the property by the time of his death in 1868.

Since Vassar had no direct heirs, the property was sold and ended up being owned by a few differ-

ent families until the mid-1960s. When the property was threatened by requests for rezoning to build apartments, preservationists banded together. A community effort succeeded in having Springside designated a National Historic Landmark in 1969. Currently, the Springside Landscape Restoration, a nonprofit organization, oversees and preserves the site. Visitors to Poughkeepsie are welcome to take a self-guided tour of this delightful oasis in the city. Springside is the only landscape designed by Andrew Jackson Downing to survive largely intact.

Storm Light on the Walkway

The opening of the Hudson River Walkway linking Highland on the west side of the Hudson and Poughkeepsie on the east in October 2009 created a state park that quickly enchanted both local residents and visitors alike and attracted many more visitors than predicted. The evolution of this recreational delight was nothing short of miraculous in a time of state parks closing due to budget constraints.

The Walkway Over the Hudson State Historic

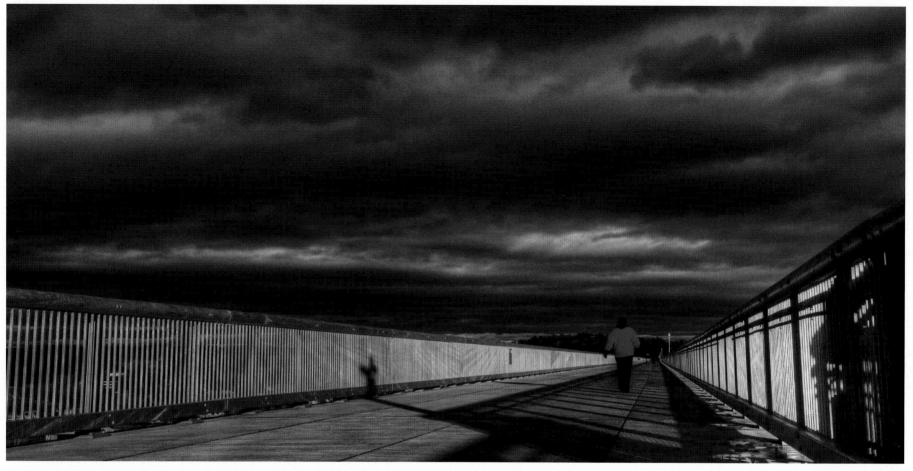

Walkway Over the Hudson

Park spans 1.28 miles and rises 212 feet above the Hudson. After a fire closed the bridge in 1974, the old steel railroad bridge became an object of curiosity to those crossing the parallel Mid-Hudson Bridge. Who could imagine it would become the longest pedestrian bridge in the world?

When Poughkeepsie industry was in its heyday, the railroad bridge opened. The year was 1889. The bridge linked the coalfields of Pennsylvania with the factories of New England. As times changed, use of the bridge declined and so did the bridge itself.

The idea of restoring the railroad bridge as a pedestrian walkway began in 1992 when one citizen, Bill Sepe, formed an organization of volunteers and called it Walkway Over the Hudson. Nothing much happened until a new board with greater vision took over in 2004 and local attorney Fred Schaeffer became involved with the project. He worked diligently with the Dyson Foundation to raise money and fulfill the dream. When work began, it took sixteen months and 38.8 million dollars to build.

People visit in a steady stream with bikes, strollers, rollerblades, and even wheelchairs. Over a half-million came in less than five months. An LED (light emitting diode) lighting system was installed that allows visitors to cross the bridge at night when

Mid-Hudson Bridge, right

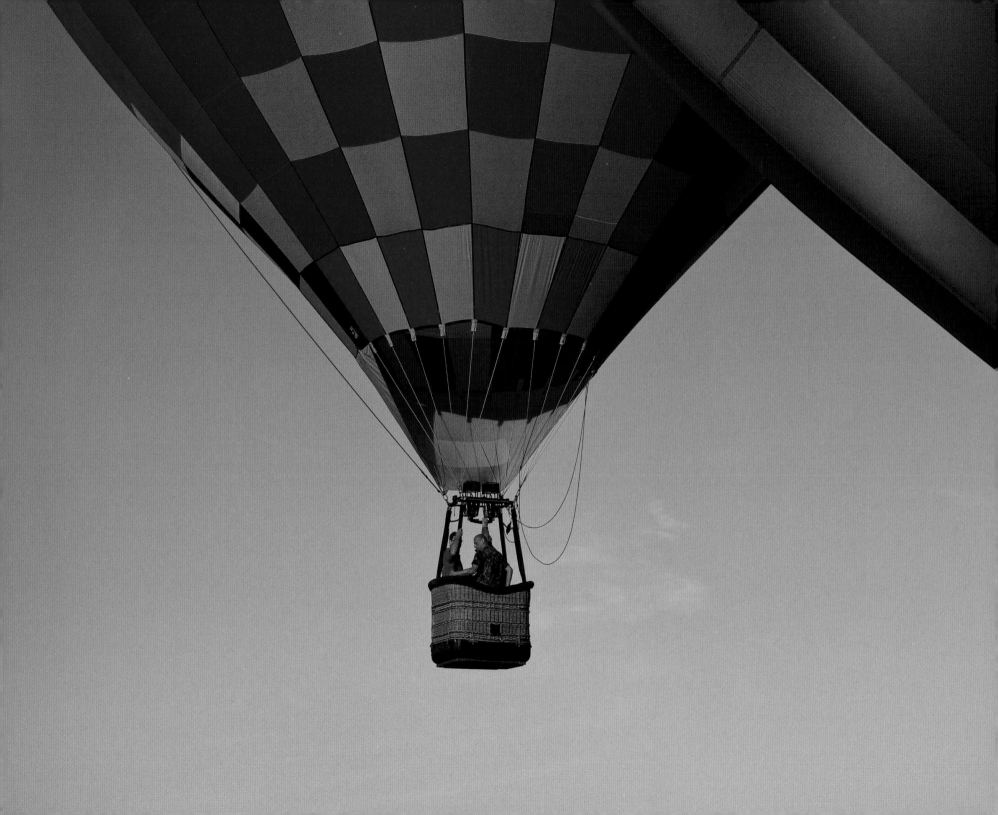

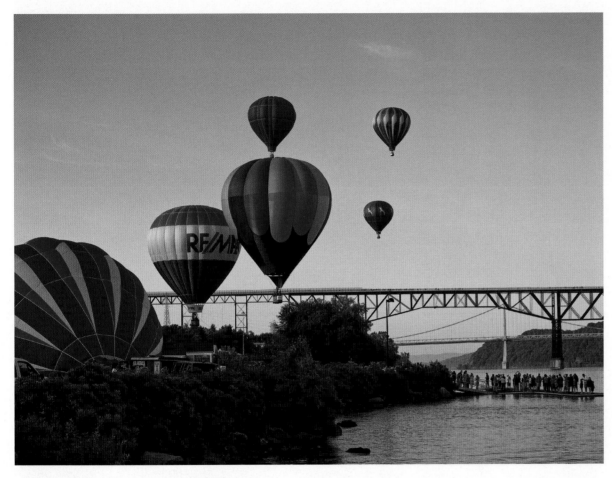

July Fourth Balloon Festival, above and left

When it was built in 1930 by the New York State Department of Public Works, the Mid-Hudson Bridge was the second span over the Hudson River (the Bear Mountain Bridge opened in 1924). In 1933 it was turned over to the New York State Bridge Authority. The cost of construction of this suspension bridge was approximately six million dollars but to replace it today would be over $220 million.

The tolls to cross the bridge were high considering the cost of living in the 1930s. A car would pay 80 cents each way and there was an extra charge of 10 cents per passenger. Today it costs one dollar and the toll is charged in one direction only, making it less expensive than it was 80 years ago!

Balloon Festival, July 4, 2010—Poughkeepsie

Keeping eyes to the skies over July Fourth weekend 2010, spectators were treated to the Mid-Hudson Balloon Festival wafting over Dutchess County for three days. Sponsored by the Dutchess County Regional Chamber of Commerce, the annual event featured balloon launches in nine different locations. While watching the colorful airships inflate and ascend, those at Waryas Park along the city's waterfront were treated to a rare spectacle. An ideal place to celebrate Independence Day!

Bardavon 1869 Opera House

The Bardavon is the oldest continuously operating entertainment venue in New York State and has been a community resource since 1869. During its first fifty years, it was called the Collingwood Opera House for the owner James Collingwood, a coal and lumber merchant who was one of the city's wealthiest citizens. This city jewel boasted Mark Twain speaking, pianist Ignacy Jan Paderewski performing, John Philip Sousa's band

there are special events. An unexpected pocket of pleasure over the Hudson River, it offers an entirely new perspective on the city of Poughkeepsie as well as the Hudson River.

Mid-Hudson Bridge

As evening descends over the Hudson River, the stately Mid-Hudson Bridge comes to life with an array of red, green, and blue lights dancing along its suspension cables. In addition to its beauty, the lighting system has the distinction of being the first application of LED bridge necklace lighting in the nation, and one of the first in the world. The 142 fixtures with over 27,000 lights were installed in the summer of 2001. These fixtures have no moving parts, consume little power, have a long life, produce virtually no heat, and emit no noise or ultraviolet light. The bridge opened in 1930 and the use of LED technology was a fine way to bring it into the twenty-first century.

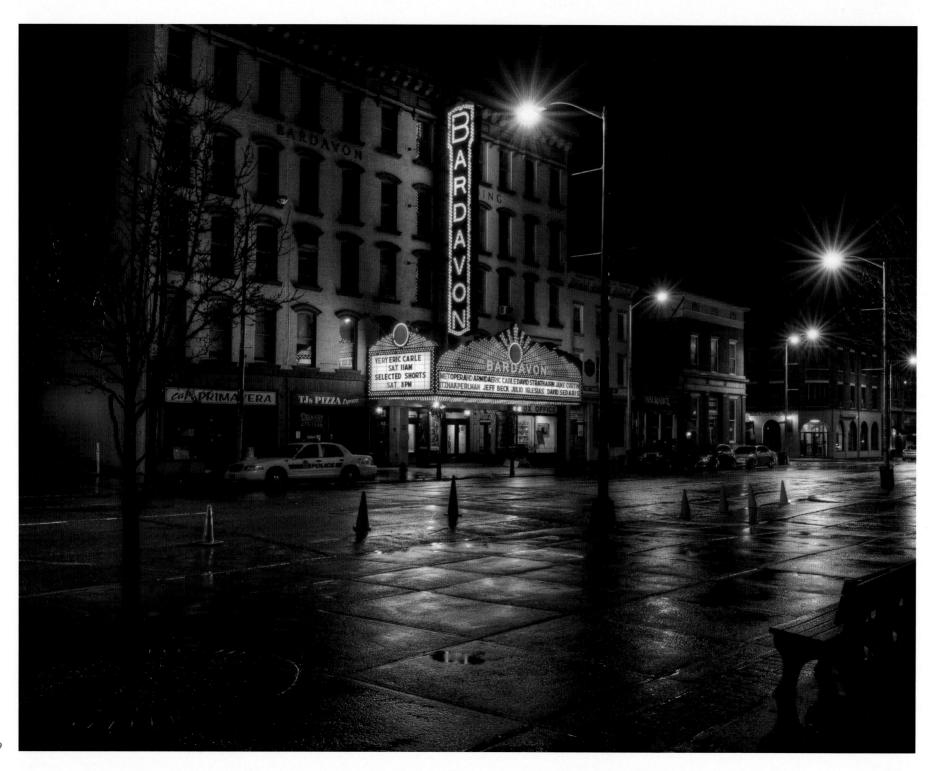

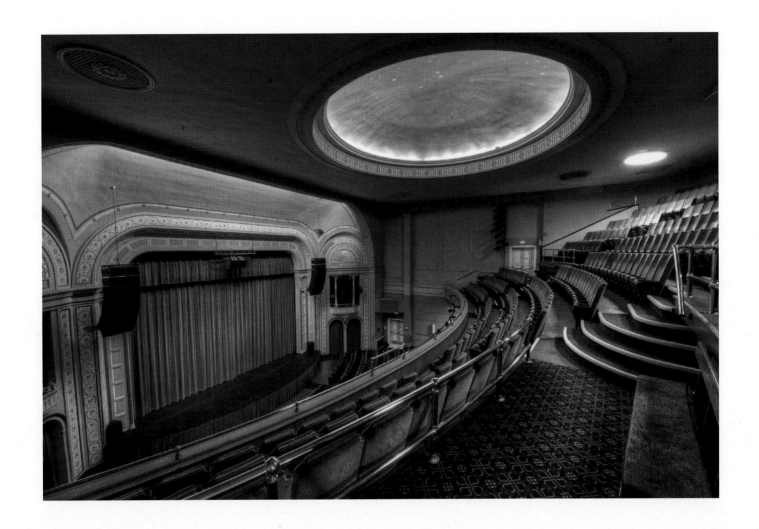

playing, and Sarah Bernhardt and Helen Hayes making appearances as well.

After Collingwood's death in 1874, management remained fairly stable but in 1923 the opera house reopened as the Bardavon Theater. Two years later it was leased by Paramount and transformed into a combination of vaude-

The Bardavon Opera House, Poughkeepsie, above

Market Street, Poughkeepsie, left

ville and film venue. A Wurlitzer theater organ was installed and movies were shown. This continued until 1975.

The theater was going to be torn down and replaced by a parking lot in the mid-1970s thanks to the ill-advised federal program Urban Renewal. However, a group of concerned citizens organized and eventually formed a not-for-profit corporation and obtained a lease on the theater. To help insure its future, the building was added to the National Register of Historic Places in

1978. Strong support from the city followed. Today the Bardavon is a hub of the city with a year-round schedule of performances and school programs.

There are still remnants of the time of Collingwood. Backstage, scenery is moved using the hemp system first installed in the opera house and the original 1869 dome is in place as well. A living museum, the Bardavon continues to meld past and present and remains a bright spot in the city's colorful history.

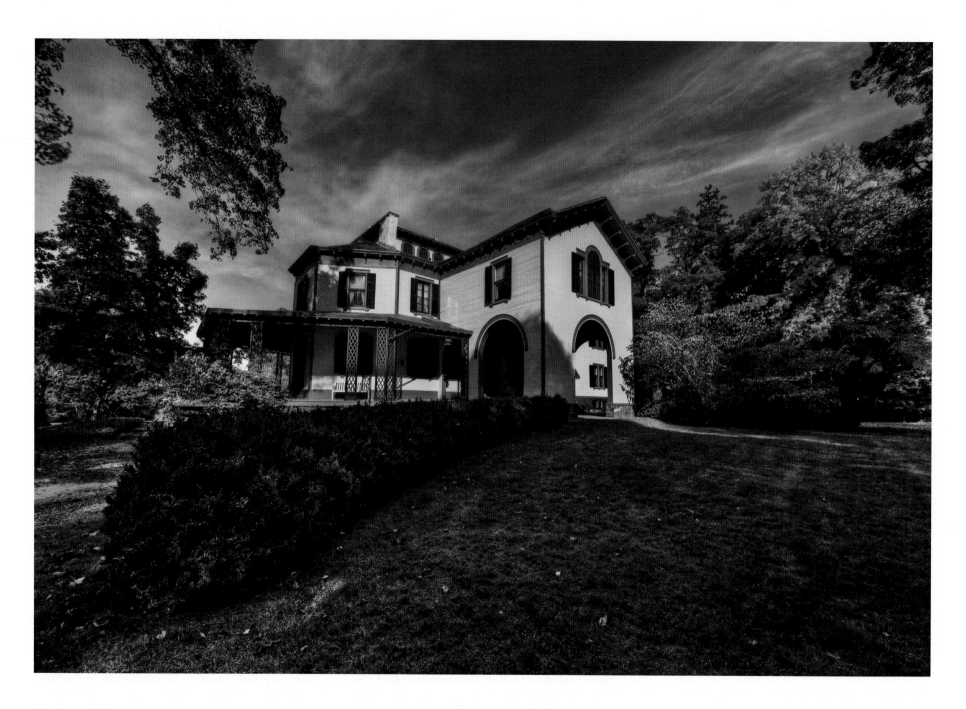

The Samuel F. B. Morse State Historic Site, Locust Grove

Locust Grove

Samuel F. B. Morse (1791–1872), inventor of the telegraph and Morse code, purchased nearly 100 acres of land from the Livingston family in 1847 for a summer residence. Working with architect Alexander Jackson Davis, the house was transformed into an Italianate villa with extensive gardens.

The Young family bought the estate from Morse's heirs in 1895 and added gardens and carriage drives along the Hudson River. Annette Innis Young, the last member of the family to live at Locust Grove, created a not-for-profit foundation to preserve the estate for the "enjoyment and enlightenment of the public" in 1975.

Samuel Morse wrote in a letter to his brother in 1848: "You have no idea how lovely Locust Grove is. Not a day goes by that I do not feel it." That sums up the spirit of this amazing property; it was declared a National Historic Landmark in 1963.

Wappingers Falls—Dutchess Stadium / Hudson Valley Renegades

Dutchess Stadium in Wappingers Falls is a boon to the community and attracts baseball aficionados from surrounding towns throughout the playing season. The Hudson Valley Renegades are a Class A minor league baseball team for the Tampa Bay Rays that play out of Dutchess Stadium. The organization has produced major league players including Scott Posednik, Joe Kennedy, Ryan Dempster, and Jorge Cantu. Doug Waechter threw the only no-hitter in the Renegades' history on August 10, 2000 against the Pittsfield Mets. In 1995, Scott Posednik became the first former Renegade to win a World Series with the Chicago White Sox defeating the Houston Astros that included former Renegades Brandon Backer and Dan Wheeler.

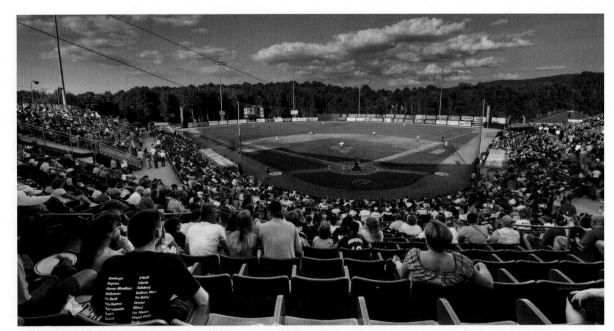

Dutchess Stadium near Beacon

Hudson Valley Renegades player stealing bases

Harvest time, Benmarl Winery

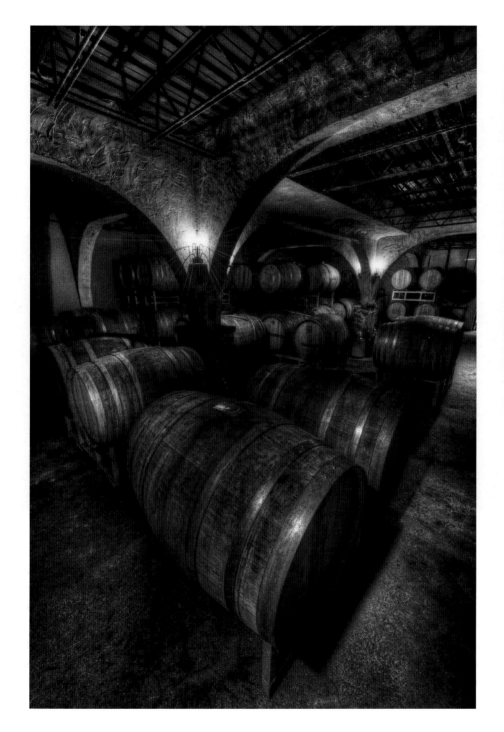

Vintner Matt Spaccarelli, Benmarl Winery, above

Wine Cellar, Benmarl Winery, left

Marlboro—Benmarl Winery

The birthplace of American viticulture is the Hudson Valley. As early as 1827 Croton Point was where the nation's first commercially successful vineyard operated. But the distinction of being the *oldest* wine-growing district in America is in the Mid-Hudson Valley, in Marlboro. As early as the seventeenth century, the French Huguenots cultivated grapes on the land that is now Benmarl and made their wine in New Paltz.

A young farmer who became involved in the Hudson Valley wine business was Andrew Jackson Caywood.

Washington's Headquarters State Historic Site, Newburgh

a history of their unit and its uniforms in the museum. A drill is conducted outside and a troop inspection by George Washington himself. These reenactments keep tradition alive and are a wonderful way to involve young people in American history.

Newburgh Waterfront

The picturesque waterfront area in Newburgh attracts visitors from all over the region—and the world. An example of such a "visitor" from afar is the *Peacemaker*, a flagship with an interesting history that sails up and down the east coast of the United States during the spring and summer months. For one week, in June 2010, the vessel docked in Newburgh.

Originally built in southern Brazil by an Italian family of boatbuilders using fine tropical hardwoods and traditional construction methods, the *Peacemaker* was launched in 1989 as the *Avany*. Owner Frank Walker, a Brazilian industrialist, had planned to operate it as a charter vessel in the Caribbean, but this never happened.

Walker ended up selling the ship in 2000, alterations were made, and it finally set sail as *Peacemaker* in 2007. Currently owned by a nonprofit corporation, the mission of the vessel is to symbolize the spirit of peace and unity among all peoples. It also provides apprenticeship opportunities for students interested in sailing, rigging, navigation, and carpentry to live aboard a ship.

Beacon

Beacon, a city once known for its hilltop casino, fine wool hats, biscuit wrappers, and red bricks, is undergoing a renaissance with the arrival of a world-class art museum, galleries, and restaurants. The river city has come back

The *Peacemaker*

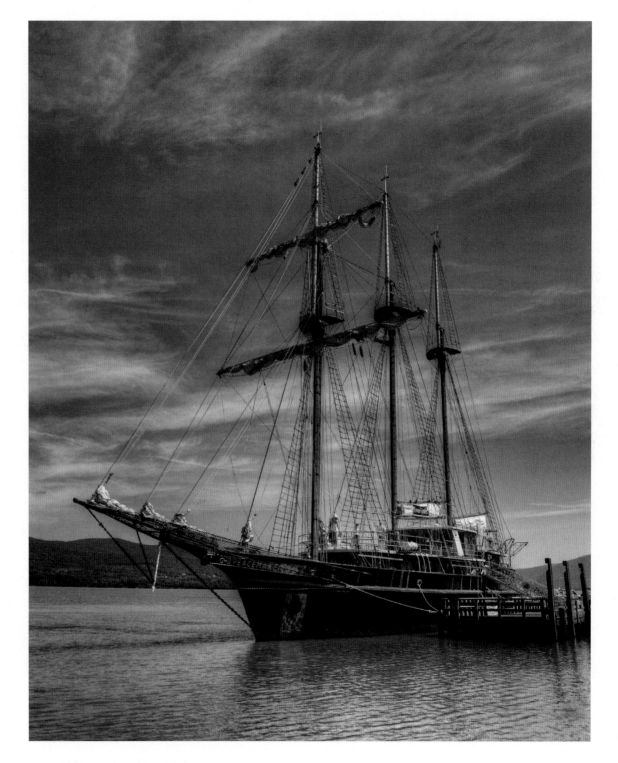

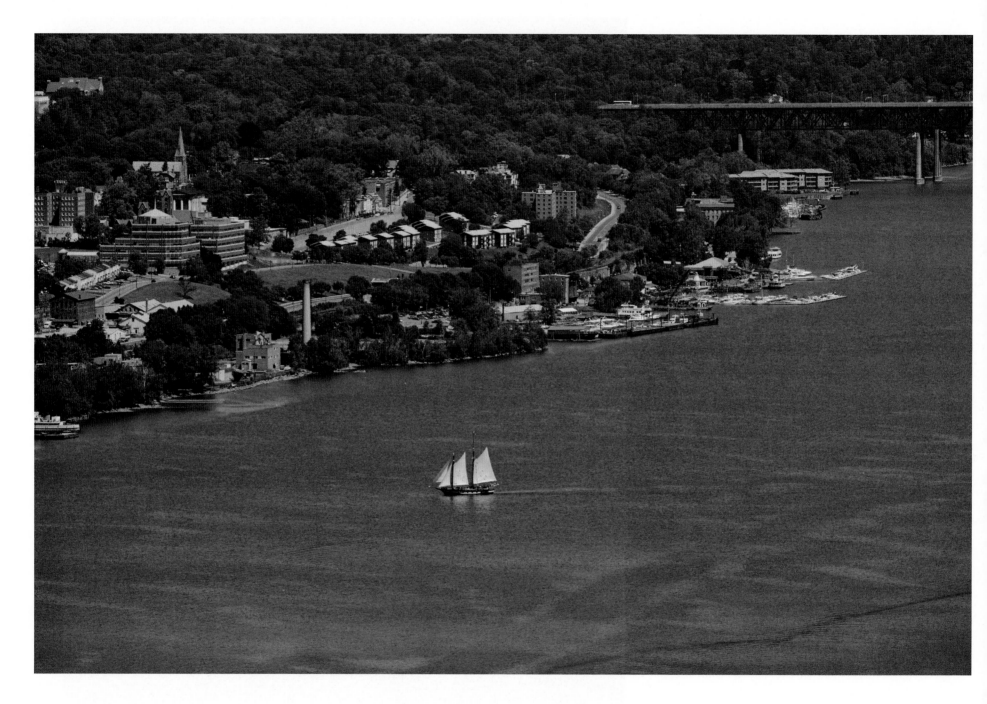

Newburgh Waterfront

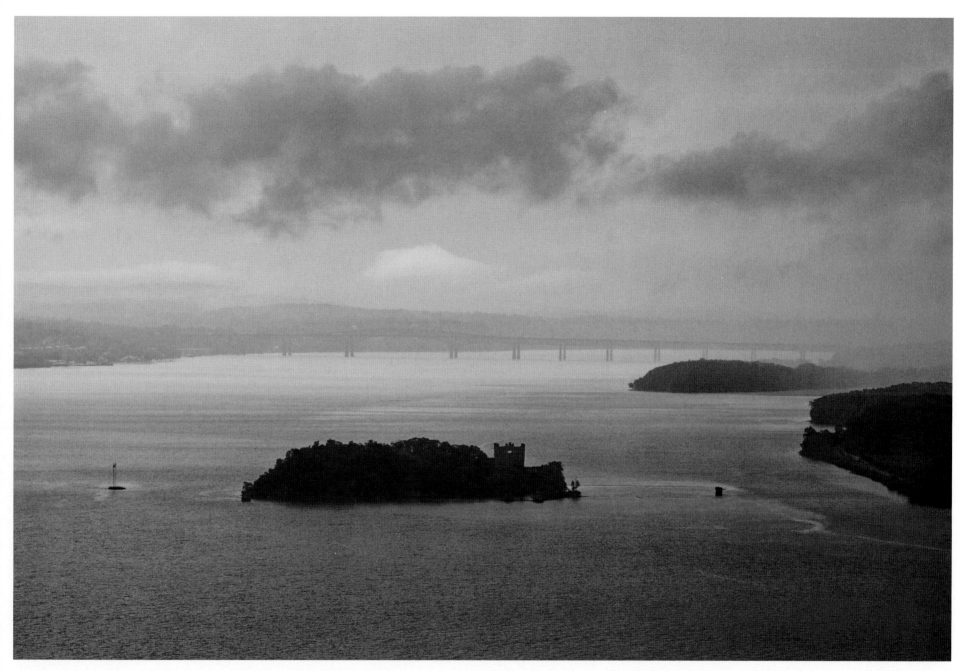

Bannerman's Island and Newburgh-Beacon Bridge, above

View from Mount Beacon, following page

to life with its restored Victorian architecture, stunning river setting, nearby hiking, and soon-to-be renovated incline railway to Mount Beacon offering spectacular views of the city, river, and mountains. The fact that the Metro North train stops within walking distance of the heart of Beacon makes this a boon for Manhattan tourists seeking an interesting day trip. People can walk, drive, or bicycle to and from the train station and it's only an hour's ride to New York City.

The ruins of hat-making, brick, and carton factories are being reincarnated as artists' lofts; once boarded-up storefronts have reopened as trendy boutiques, and an abandoned industrial building reopened in 2003 as a shrine to modern art, Dia:Beacon. The city's name came from signal fires that were atop nearby Mount Beacon during the time of the Revolution. During the 1800s, the city became a factory town and was known as the Hat Making Capital of the United States with nearly five hundred hat factories operating at the same time. In the 1960s urban renewal led to the destruction of several historic buildings, and during the late 1970s, the Dutchess Ski area closed and an economic decline resulted in most factories shutting their doors. The downturn lasted from 1970 until the early part of the twenty-first century when Dia arrived.

A recent addition to the city is Long Dock Park, a 12-acre public parkland on the banks of the Hudson River and a short walk from the train station. The area offers lovely walking trails and a kayak center while surrounded by wetlands. The Scenic Hudson Land Trust received a grant of three million dollars from the Empire State Development Corporation to assist in design and construction of the park and worked with community leaders in its development.

While the town still bears the scars of prolonged economic hard times, Beacon is growing and changing in a positive direction and continues to attract new

residents from the metropolitan area and beyond who bring new energy and vision to the city.

Incline Railway

Beacon celebrates its Centennial year in 2013, and it is possible that will be the year when the refurbished Incline Railway on Mount Beacon will be back in business. City planners estimate the attraction would lure nearly a half-million visitors each year, the majority from outside the city of Beacon.

The Mount Beacon Incline Railway originated in 1902 as a cable railway boarding at the base of Mount Beacon traversing 2,200 feet of track rising 1,540 feet to

the station at the top. The five-minute trip was a tourist attraction ridden by about 3.5 million people until 1978 when it shut down. The railway was destroyed by fire in 1983. Visitors are still intrigued by Mount Beacon, surrounded by 234 acres of parkland now owned by the Scenic Hudson Land Trust, offering spectacular views of the Hudson River and Catskill Mountains . . . but they must climb up to the park.

Beacon Institute for Rivers and Estuaries

The Beacon Institute for Rivers and Estuaries, a not-for-profit organization, has initiated programs to better understand the Hudson and other rivers around the

Geothermal, Beacon Institute, above

Beacon Institute for Rivers and Estuaries, left

world. An integral part of the ongoing renaissance in the city, it is headquartered on Main Street.

In 2007 the institute and IBM (and later, Clarkson University), joined to create REON, the River and Estuary Observatory Network, the first technology-based monitoring and forecasting center for rivers and estuaries. The institute has been following the progress of the dredging operations of General Electric to remove PCB contamination in the northern part of the Hudson River. (Scientists study how the PCBs attach to particles in the river, and the institute is interested in how these particles move through the Hudson.) The Hudson River is an ideal place to explore the interaction between people and nature.

The Beacon Institute is committed to developing a group of scientists, engineers, educators, and policy experts whose collaborative work will focus on the most endangered bodies of water in the world. While the Hudson River is the laboratory for the work of the institute, the technology developed in the Valley will be applied to rivers and estuaries around the globe. Access to clean water is one of the most pressing problems throughout the world.

One of the most exciting aspects of the Beacon Institute is the Center for Environmental Innovation and Education (CEIE), its primary education facility. Equipped with surround-sound video conferencing and broadcasting capabilities, the building can be used for seminars, exhibits, and cultural events. Additionally, the CEIE is a visitor center for Denning's Point (part of the Hudson Highlands State Park) where there is public access to the Hudson River and a network of walking trails.

A model of green design created by Gensler, a global design firm, the CEIE includes state-of-the-art technology at every turn. From top to bottom, the

Old building, East Main Street, Beacon

Dia:Beacon

4,000-square-foot building embodies the institute's commitment to energy efficiency, sustainability, and green building technology. There are composting toilets throughout the facility. Both solar and geothermal technologies are employed in the heating and cooling systems. A "green" roof is chock-full of indigenous plants. And last, but not least, a specially engineered permeable parking lot allows rainwater to be filtered into the soil below.

The green innovative design nicely integrates the CEIE into the surrounding historical landscape. Sustainable principles employed throughout the building are sure to garner LEED (Leadership in Energy and Environmental Design) certification for this marvelous gem in the midst of Beacon.

Artists' Lofts—Combining Old and New

In 1996, Robert Chiulli, a Yonkers developer, bought an abandoned nineteenth-century textile mill in Beacon to be used as commercial storage space. Chiulli realized Beacon's community of artists was growing, and he expanded his original plans to include living space to accommodate these newly arrived residents. He purchased the 200,000-plus-square-foot property and invested a great deal of money into two factory buildings. This area was once a workplace for 2,000 people in the factory's heyday yet would now offer space where artists could both live and work. Decades of paint were sandblasted off the bricks. The building was cleaned without damaging a single block or any of the original mortar inside or outside, a testament to the quality of the workmanship the laborers put into the construction when it was built over a century earlier. The abandoned building was transformed into an asset to the community, creating affordable live-and-work lofts for artists.

Dia:Beacon

Andy Warhol, Joseph Beuys, and Donald Judd are among the artists of the 1960s and 1970s who experimented with light, space, dimension, and shape in huge sculptures or paintings. The Dia Art Foundation stored their art because the nonprofit had no place sufficiently spacious to display it.

International Paper donated to Dia a former warehouse known as "The Biscuit" by local residents where labels for Nabisco products had been printed. Built in 1929, this 292,000-square-foot steel, concrete, and glass structure with an extensive system of skylights offered the perfect place to showcase the Dia art collection. Surrounded by twenty-six acres of land, it is located on the banks of the Hudson River, a short walk from the train station. The space itself is as intriguing as some of the artwork and has been attracting thousands of visitors from all over the world since opening in 2003.

Old Dam, Fishkill Creek

The waterfall of Fishkill Creek goes right through downtown Beacon along East Main Street. Flowing water

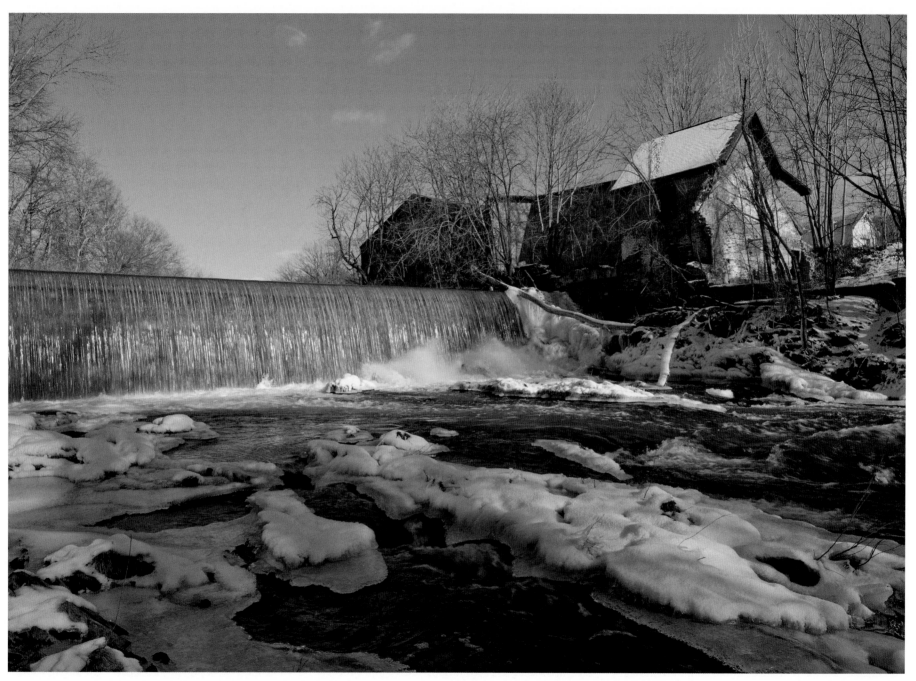

Historic Dam, Fishkill Creek, Beacon

from the creek, formerly harnessed by the factories in town, is now simply enjoyed for its beauty, a respite from the hustle and bustle of Main Street.

Local Artwork

With the arrival of Dia in Beacon, the city began attracting artists of all stripes. Second Saturdays in Beacon is a citywide celebration of the arts held the second Saturday of every month when shops stay open until 9 p.m. Gallery openings and music add to the lively atmosphere, and all the festivities make this an ideal time to visit the city.

Beacon Falls Café

After the influx of artists and tourists to the city, cafes and restaurants soon followed. Beacon Falls Cafe, an American bistro on Main Street, is one of those new arrivals. Chef/owner Bob Nevelus features creative variations on comfort food at affordable prices in an effort to appeal to both local residents and visitors.

Beacon Point—Peter Jay Sharp Park

Peter Jay Sharp Park on Scenic Hudson's Long Dock waterfront property is a 2.5-acre recreation area named in honor of a devoted patron of the arts who largely funded this public space. Artist George Trakas created the riverside sculpture with an elegant boardwalk, terraced fishing platforms, and a design that interacts with the tidal changes of the Hudson River.

The beauty of this city is that it's only a short walk from Main Street to Beacon Point to take in a magnificent sunset and sculpture . . . free of charge, of course!

Beacon Falls Café

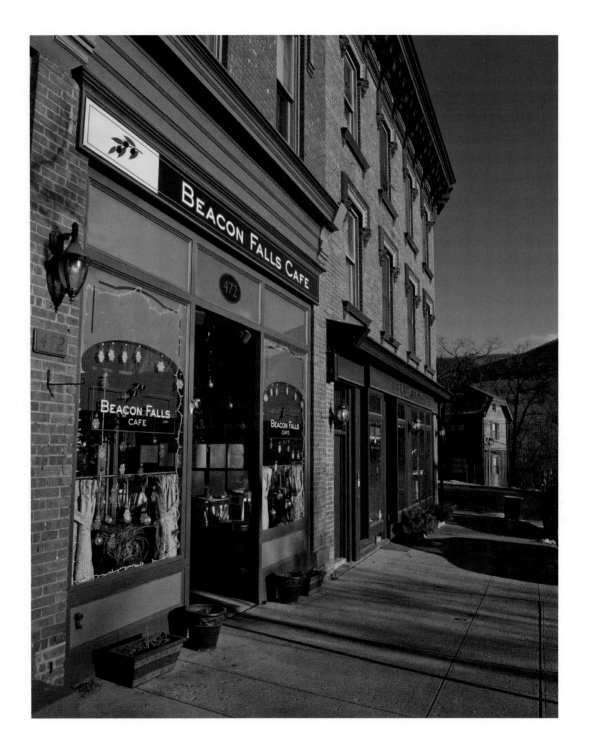

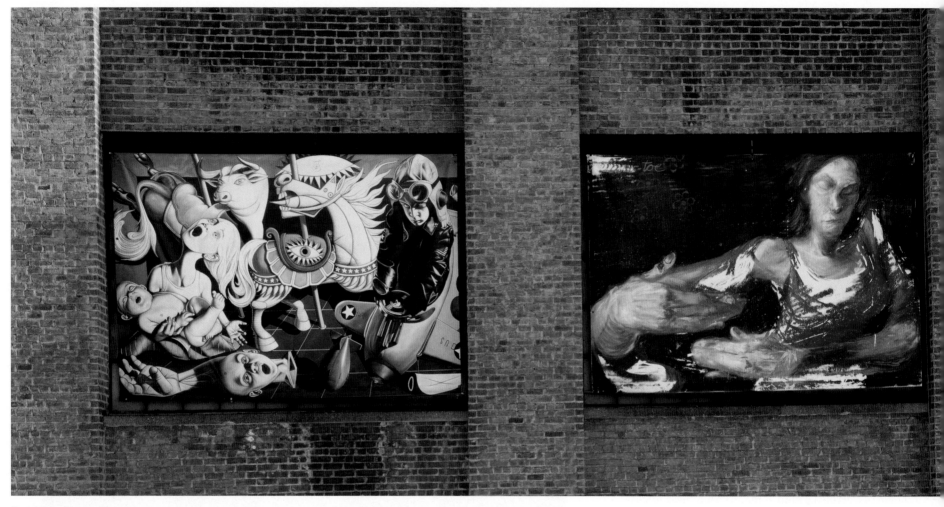

East Main Street, Beacon

Cornwall-on-Hudson—Donahue Memorial Park

Donahue Memorial Park, on the banks of the Hudson River in Cornwall, is a popular destination for both tourists and local residents, unless the weather looks ominous. The gazebo is an excellent place to take photographs, and the park itself is often used to showcase large sculpture exhibits as well as holiday festivities.

There is a monument honoring the park's namesake, the late Dr. Michael Donahue, a veterinarian as well as trustee and mayor of the village. Interestingly, Dr. Donahue supported Consolidated Edison's unsuccessful quest to build a hydroelectric power plant on Storm King Mountain. The battle raged on for seventeen years and ended in 1980 when Scenic Hudson demonstrated how a grassroots effort could force a

large corporation to back down. Ironically, as a result, there are still unspoiled river views from Donahue Memorial Park.

Cold Spring

Legend has it that George Washington drank from a local village spring and declared it to be refreshingly cold, hence

94

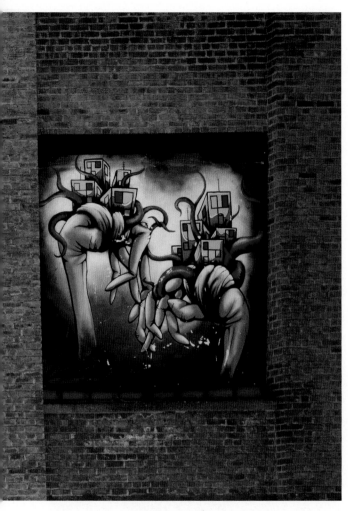

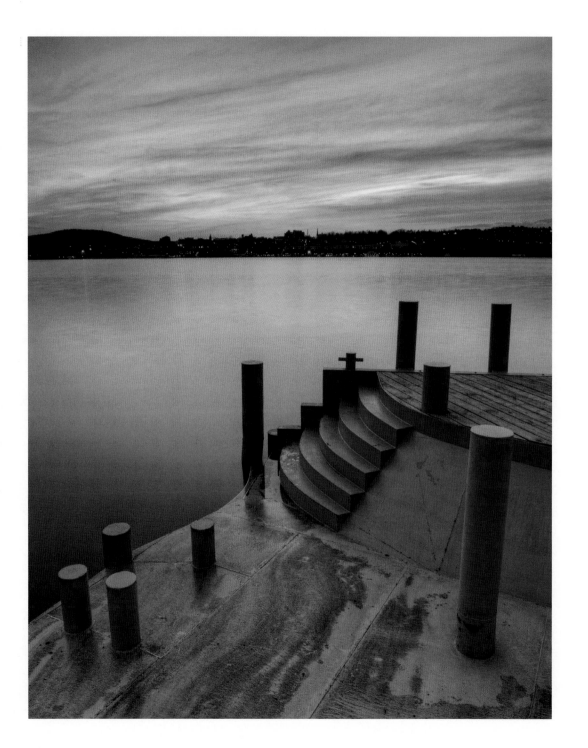

George Trakas Pier, Beacon Point, right

the name. The first settler in Cold Spring was Thomas Davenport in 1730, and during the eighteenth century a small trading hamlet grew up along the Hudson River. Cold Spring was a region rich in natural resources. The area where Fahnestock State Park is located provided plentiful lumber and iron ore. Margaret's Brook, a small creek that runs into the Hudson River, became a source of hydropower to the West Point Foundry established in 1818.

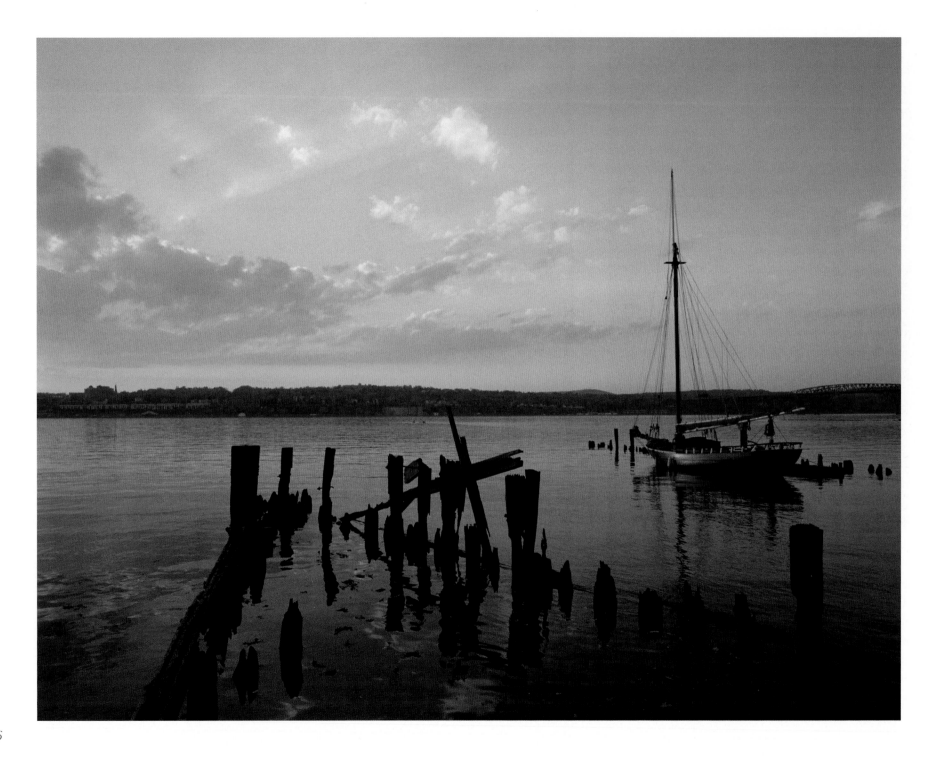

Gazebo, Donahue Memorial Park, above

The *Woody Guthrie*, Beacon waterfront, left

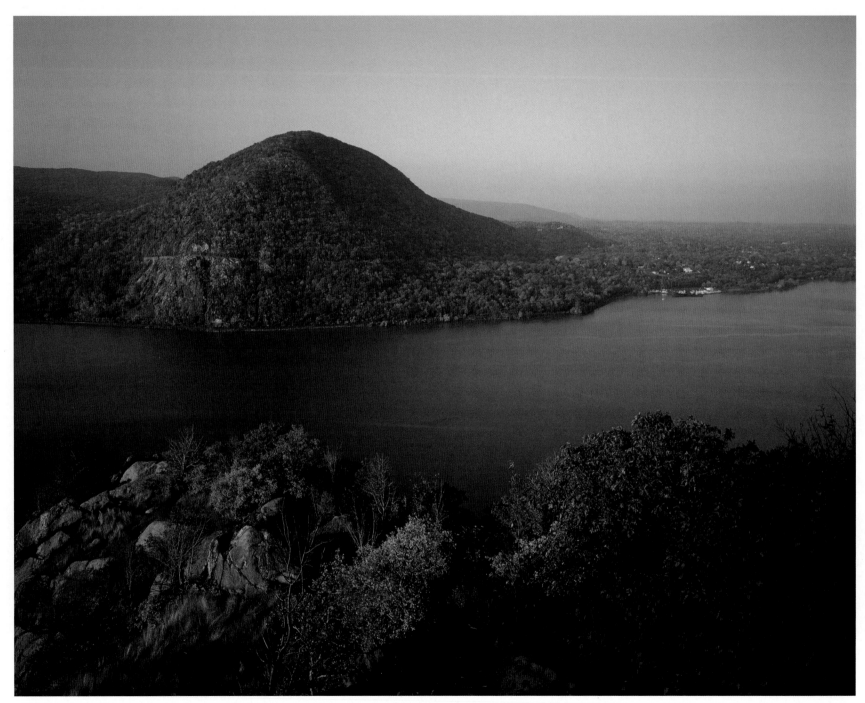

Storm King and Cornwall-on-Hudson (view from Breakneck Ridge near Cold Spring)

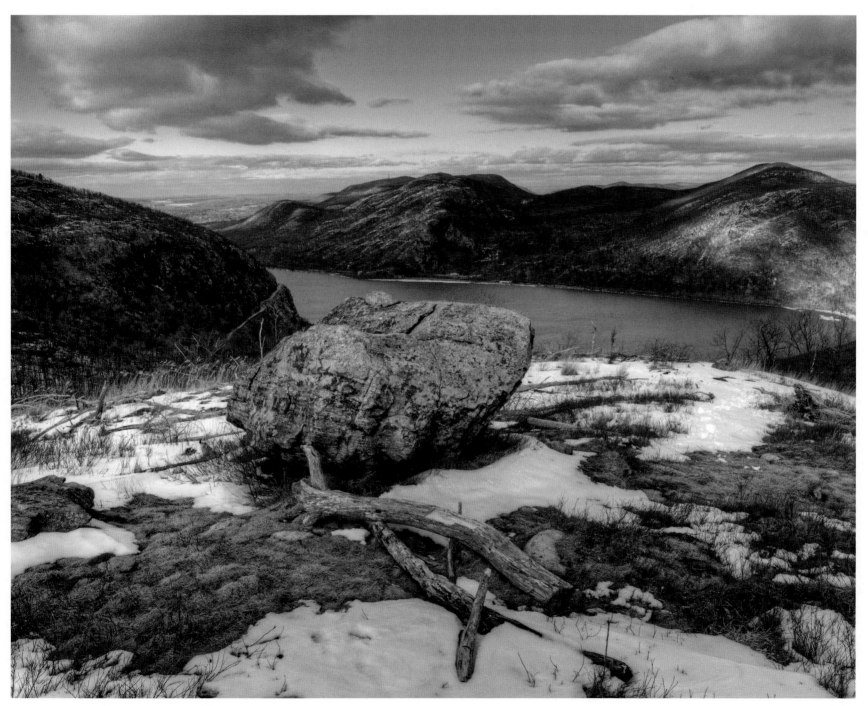

North Point, Storm King State Park

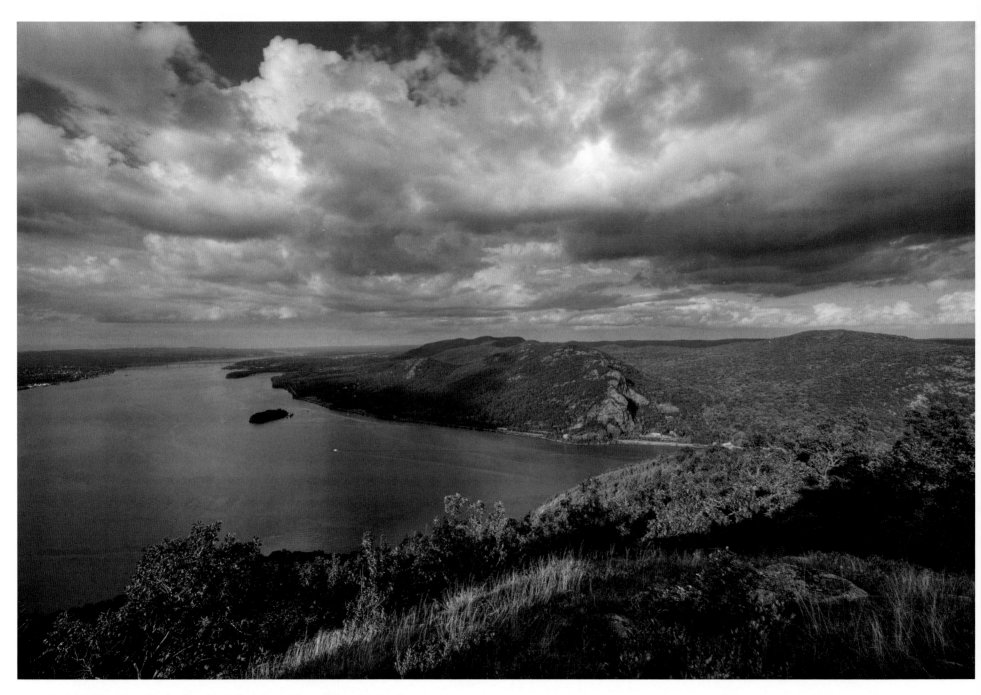

Hudson River view, Storm King State Park (near Cornwall-on-Hudson)

Cold Spring Fall

The subsequent influx of workers led to growth in the village and it was incorporated in 1846.

By the late nineteenth century Cold Spring had become a popular area for artists, writers, and wealthy families, all attracted by its stunning beauty. After the foundry closed in 1911, the village became quiet, but not for long. When World War II ended, commuters to New York City discovered the town. Businesses followed, and in 1973 the village was designated a Federal Historic District. In recent years, travelers have been lured to Cold Spring by its historic sites, fine restaurants, unusual shops, and the recreational activities in and around town. Unlike some Hudson River towns, Cold Spring has retained its charm and small village character, a credit to its residents who have adapted to the needs of the present while preserving their heritage.

Bare Trees and Buildings—Howell Trail Views

Cold Spring offers wonderful trails along the Hudson Highlands, often considered a place with the most spectacular views of the Hudson River.

Dockside Waterfront Park

When early Dutch explorers sailed into what is now known as the Hudson River Highlands, they called it "Wey Gat" or Wind Gate, later translated as Northgate, and today known as Dockside Harbor. It is the area where the Hudson River is at its deepest point (216 feet).

In 1999 the Open Space Institute ensured the preservation of the 7-acre Dockside Waterfront Park and twenty acres in the harbor and secured forever public access to the river at this point. The views here are phenomenal with Breakneck Ridge to the north, West Point to the south, and Storm King Mountain directly across the river to the west.

Chapel of Our Lady

Several Hudson River School painters visited this area to sketch the scenery, including Thomas Cole, who painted Storm King Mountain, once called Butter Hill by the Dutch. In the 1880s when the mountain across the river became the subject of several paintings, it was decided that a more evocative romantic name was needed. "Storm King" was selected to replace Butter Hill by Nathaniel Parker Willis, a renowned author, poet, editor, and Hudson Valley resident, who worked with both Edgar Allan Poe and Henry Wadsworth Longfellow, and the name stuck.

Cold Spring Waterfront

A visit to Cold Spring isn't complete without a stroll down to the waterfront to take in the magnificent views of the Hudson River and surrounding mountains. A Parrott gun, the weapon manufactured at the West Point Foundry and credited with helping the Union Army win the Civil War, was installed in the center of the park in 1995, a reminder of the village's industrial past and the critical role it played in American history.

Chapel of Our Lady

Many of the laborers working at the West Point Foundry were Irish Catholics. In 1834, on a rocky point facing the river, the foundry built a small Greek Revival–style church, the Chapel of Our Lady. It is believed to be one of the oldest Catholic Churches built in the Hudson Valley.

Ruins, Foundry Cove Trail (West Point Foundry Cove Preserve)

Often covered in overgrowth, the iron mines and furnaces in the Hudson Valley are what remains of a once-

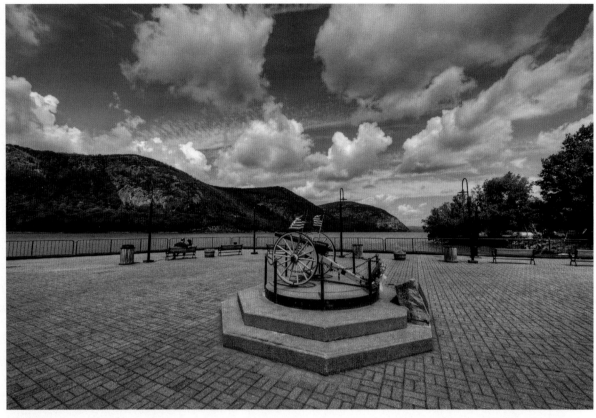

Parrot gun, Cold Spring waterfront

thriving industry. A detailed history of these foundries is provided by Thomas Rinaldi and Robert Yasinsac in their excellent book *Hudson Valley Ruins: Forgotten Landmarks of an American Landscape* (University Press of New England, 2006). The first foundries appeared in the region in the mid-eighteenth century when iron mines were established to provide colonists with tools for farming and cooking. After the War of 1812, President James Madison mandated four federally subsidized foundries be built to manufacture heavy artillery for national defense purposes. One of the locations was the Hudson Highlands; this is how the West Point Foundry

originated. Although the village of Cold Spring didn't exist, as the foundry burgeoned, houses and shops grew up along the waterfront.

During most of the nineteenth century, the West Point Foundry manufactured Parrott guns (the rifled cannon responsible for the Union Army winning the Civil War), steam engines, water wheels, and mill equipment. Robert Parker Parrott, the foundry's superintendent, is credited with giving the Union Army this superior accuracy and firepower with his invention.

The foundry also became one of America's major suppliers of commercial iron products in the early

104 Office in the Woods, West Point Foundry Cove Preserve

Founding Brook Falls, West Point Foundry Cove Preserve

nineteenth century including railway locomotives and machinery. The company reached its peak of production during the Civil War, but went into a sharp decline after the war ended. The foundry had a succession of owners over the next century, but by the 1950s manufacturing had ceased on the site. In 1973 it was added to the National Register of Historic Places.

The ruins are a part of Cold Spring's heritage. Since 1996 the 87-acre site has been owned by the not-for-profit environmental organization Scenic Hudson Land Trust. The furnaces are long gone, and the noise of the trip hammer has given way to the sound of water flowing down through the Foundry Brook. Many buildings have been reduced to ruins, and a forest has grown up around what was once a symbol of American industrial innovation.

However, an exciting future lies ahead for this public park. It has been selected to participate in a new program testing America's first rating system for green landscape design, construction, and management, the Sustainable Sites Initiative (SITES). The goal of the initiative is to create a world-class outdoor museum recounting the ironworks' groundbreaking role in America's emergence as an industrial superpower. In the near future, the park will be part of the national effort to create sustainable landscapes and revolutionize the way public spaces are designed, built, and managed.

Main Street, Cold Spring

Most travelers visit Cold Spring to browse in such shops as Once Upon a Time Antiques with its variety of treasures and Hudson Valley Outfitters where they will find everything needed for a kayak outing on the Hudson River. Later they may enjoy dining in one of its fine restaurants like Cathryn's Tuscan Grill or perhaps stay overnight at the Pig Hill Inn Bed & Breakfast. These

Once Upon a Time Antiques, Main Street, Cold Spring

Cathryn's Tuscan Grill, Main Street, Cold Spring

thriving businesses may be found on Main Street in Cold Spring along with many more intriguing stops. After taking in the hustle and bustle of the village, visitors should not neglect to venture over to West Point Foundry Cove Preserve, a peaceful oasis and a reminder of the area's prominence in days long past.

Constitution Marsh (located between Cold Spring and Garrison)

The Constitution Marsh Audubon Center and Sanctuary, a 270-acre tidal wetland between Cold Spring and Garrison, provides foraging and nesting habitat to over 200 species of birds and 30 species of fish. Some of the common breeding birds to be found here include Marsh Wren, Louisiana Waterthrush, and Spotted Sandpiper. Audubon has managed the marsh as a wildlife sanctuary since 1970, offering visitors a close-up glimpse of river life for over 40 years. A 700-foot boardwalk offers great views of the U.S. Military Academy at West Point and

Hudson Valley Outfitters, Main Street, Cold Spring

Fourth of July Parade spectator

the Hudson Highlands. The education center features ongoing public programs, making the sanctuary an unusual community asset, particularly for young residents of Cold Spring and Garrison.

Boscobel (Garrison)

Completed in 1808 for the States Dyckman family, Boscobel is regarded as one of the best examples of Federal architecture in America. It contains an extensive collection of Federal-period furniture and decorative arts, many crafted by renowned New York cabinetmakers Duncan Phyfe and Michael Allison.

The house remained in the family until 1888 and until 1955 had several owners, including the federal government, who sold it for $35 to a contractor. The house was stripped of many of its architectural details and local people tracked down the items that had been sold, restored the house, and finally purchased land to reconstruct the building. As a result of their efforts, visitors today may enjoy the house as it was in its nineteenth-century splendor. There is an art gallery on the property with changing exhibits featuring paintings by Hudson River School artists.

The grounds at Boscobel are renowned for their exquisite gardens and phenomenal views of the Hudson River. During spring and summer there are outdoor performances by the Hudson Valley Shakespeare Company; this is also when thousands of flowers are in full bloom, including tulips, daffodils, roses, pansies, and wildflowers. Boscobel should not be missed on any trip to Garrison!

Pig Hill Inn, Main Street, Cold Spring

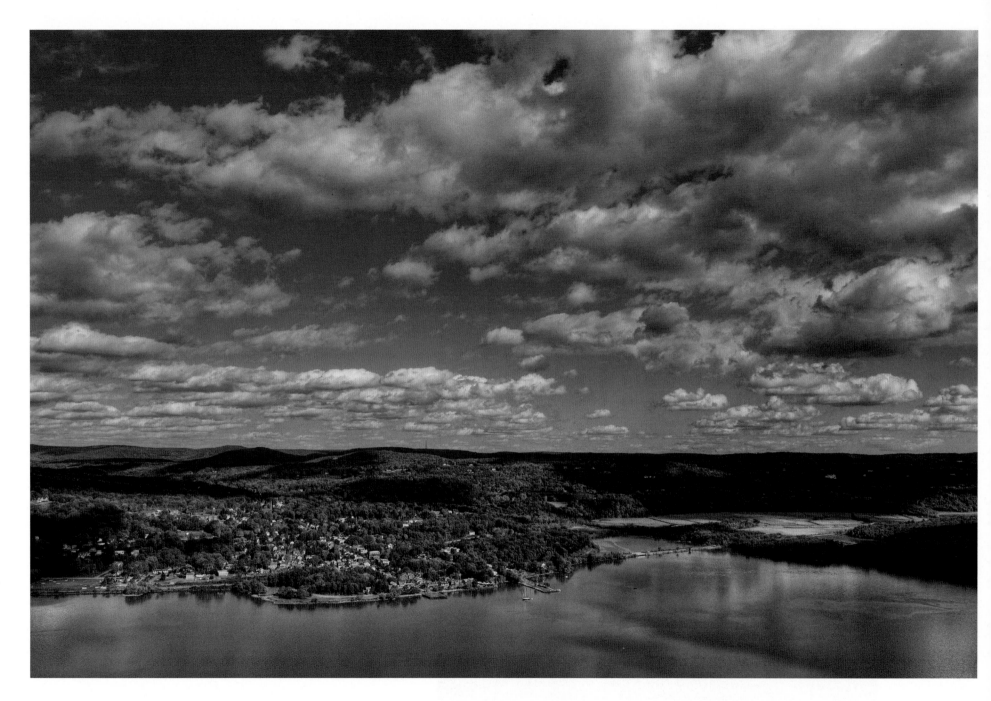

Cold Spring and Constitution Marsh, Hudson River

Boscobel

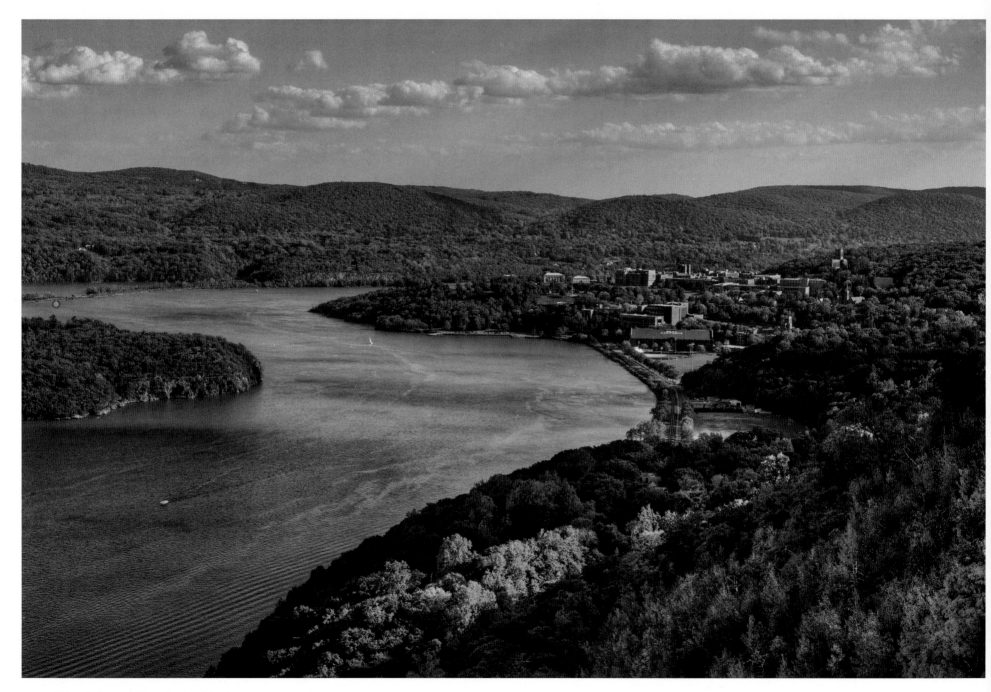

West Point and Constitution Island

St. Philip's Church in the Highlands

The historic St. Philip's Church in the Highlands, an Episcopalian church in Garrison, can trace its beginnings back to 1770. However, for decades the parish had a few different locations between Peekskill and Garrison.

The arrival of the Hudson River Railroad in 1845 brought many new families to the Garrison area and ushered in a period of expansion for the church over the next fifteen years. During that time several prominent residents settled in the area including the Upjohns, the Fish family, the Sloans, Osborns, and Pierponts. In 1860 parishioners raised $10,000 to construct a new Victorian Gothic granite church designed by church architect Richard Upjohn, a Garrison resident and vestry member of St. Philip's. The new structure was consecrated in 1862.

Today as travelers make their way through Putnam County on Route 9D, the beautiful St. Philip's Church commands attention; it was added to the National Register of Historic Places in 1995.

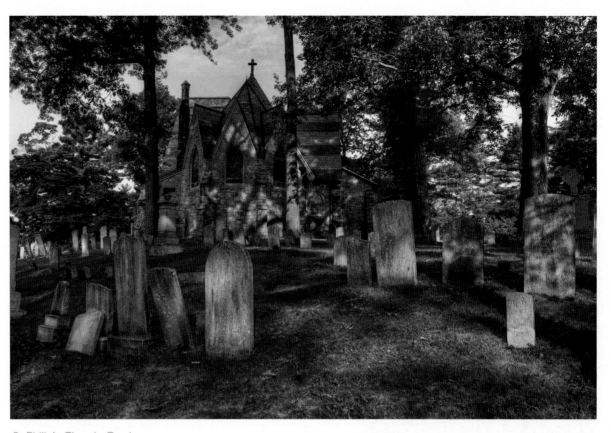

St Philip's Church, Garrison

West Point

Considered to be the most important strategic position in America by General George Washington, West Point is the oldest continuously occupied military post in America. Continental soldiers extended a 150-ton iron chain across the Hudson to maintain control over river traffic. In the event of an enemy attack, West Point would still be secure. Ironically, the most dangerous threat turned out to be from within. In 1780 General Benedict Arnold, commander of the fort at West Point, agreed to surrender West Point to the British in exchange for 6,000 pounds. The plot was uncovered before West Point fell into British hands, and Arnold fled to avoid prosecution. Although he avoided capture and was given a commission in the British Army, he was unable to escape the taint of his treason. He died impoverished in England in 1801, mistrusted by both the Americans he had betrayed and the British who had bribed him.

The United States Military Academy occupies twenty-five square miles of magnificent land along the Hudson River. Washington proposed creation of the academy in 1783, however the academy wasn't established until 1802 under President Thomas Jefferson. Critics within the government viewed the idea of a military school to train army officers as too European and incompatible with democratic institutions, hence it took almost twenty years before Jefferson signed the legislation.

West Point became an important institution in engineering and the sciences in pre–Civil War years. Later in the nineteenth century there was more emphasis placed on the military curriculum and graduates from the army officers corps. During World War I, West Point graduates were in charge of almost every staff bureau. In World War II, the Korean conflict, and Vietnam, the majority of officers were graduates of West Point. Today there is a broad-based curriculum emphasizing liberal arts subjects as well as more technical ones.

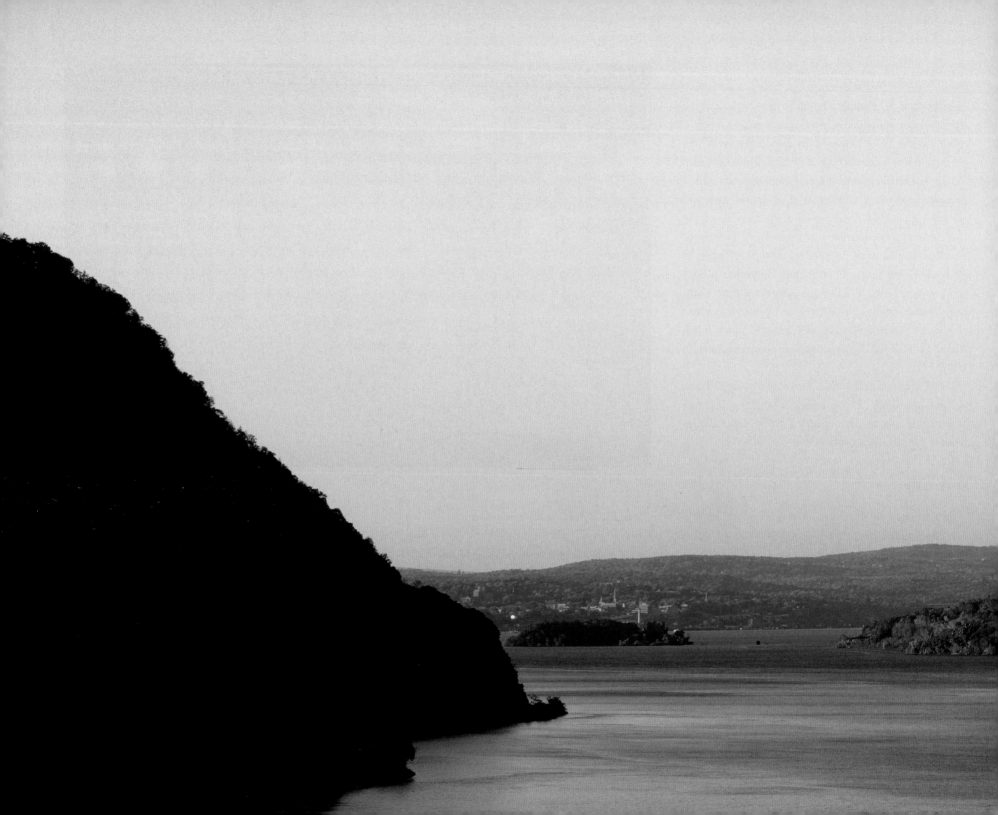

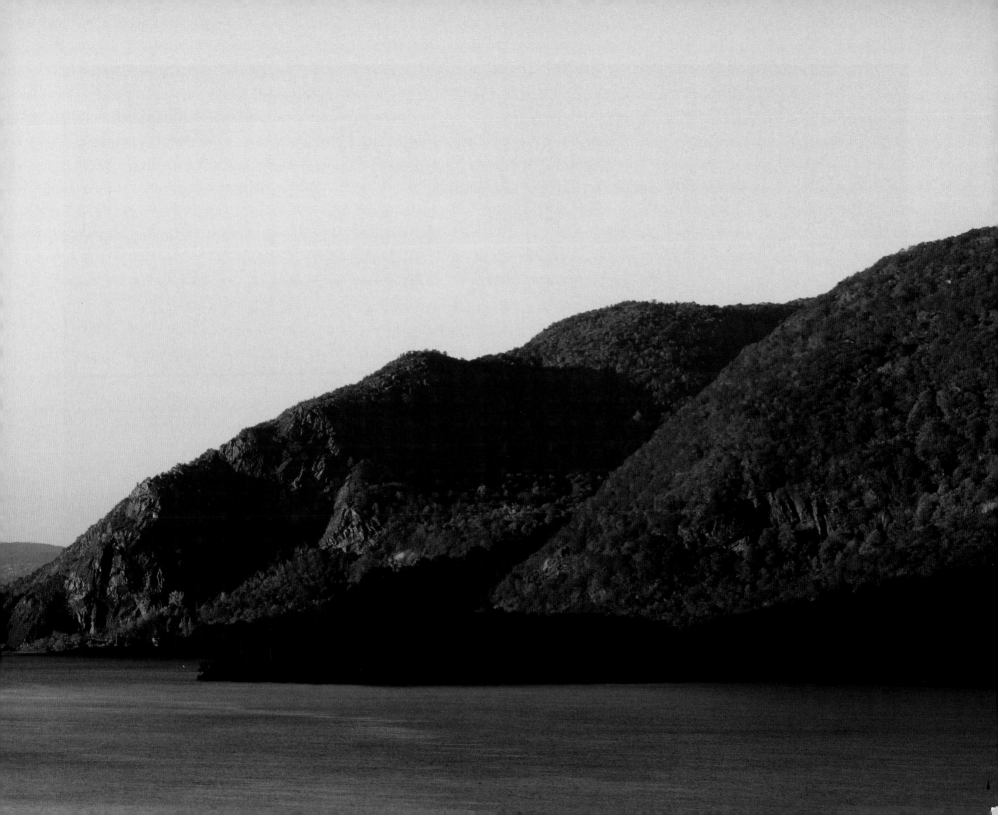

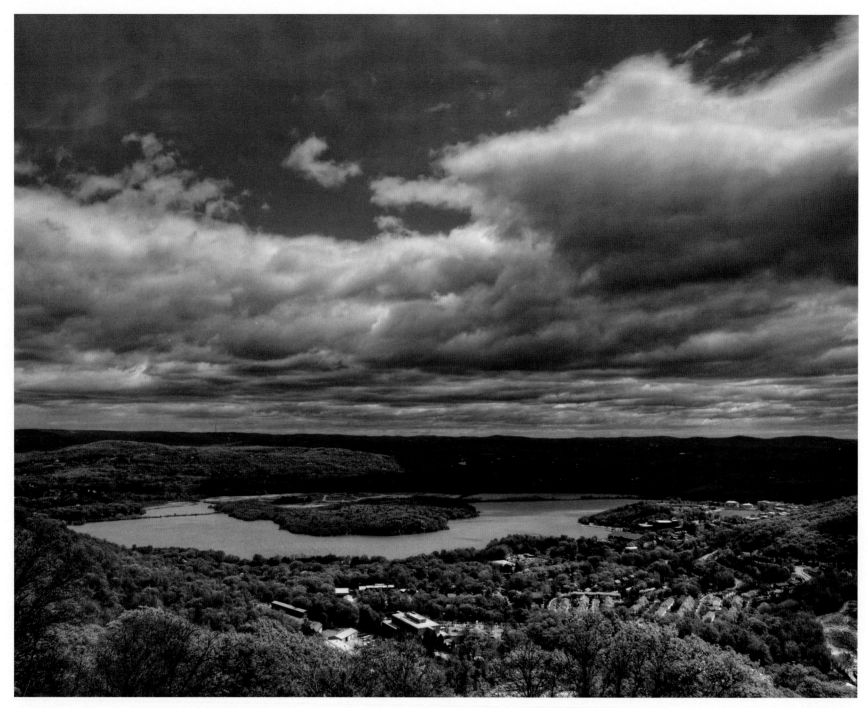

West Point

There are 4,400 cadets at West Point today. In 1877, Henry O. Flipper became the first African American to graduate from West Point. In 1976 the first female cadets were admitted to the school and Andrea Lee Hollen, a Rhodes Scholar, was the first woman graduate in 1980. Women currently make up approximately 17 percent of all cadets.

Few citizens realize that a West Point building was designated the official silver bullion depository for the country. Built in 1937 as a storage facility for silver, it came to be known as the "Fort Knox of Silver." In 1980 gold medallions began being minted here, and on March 31, 1988 West Point gained official status as a U.S. Mint. Approximately twenty billion dollars in gold is stored in the vaults. West Point is a major producer of both silver and gold commemorative coins as well as a storage facility. The Platinum Eagles have been popular since 1997 when they were first issued. In 2000 the first Gold and Platinum Bi-Metallic Coin was created at the West Point Mint.

Battle Monument / Trophy Point

Trophy Point commands a view of the Hudson as far north as Newburgh and derives its name from the numerous displayed pieces of captured artillery that span from the Revolution to the Spanish-American War. At the east end of the display is the Revolutionary War area overlooking the Hudson River. Thirteen links of the great chain that stretched across the Hudson River to Constitution Island during the Revolutionary War are located here.

The Battle Monument at Trophy Point is a Civil War memorial dedicated in 1897 to the memory of the officers and men of the Union Army who fell in battle. There are 2,230 names engraved on the monument. Designed by an architectural engineering company that included Stanford White, the monument is the largest

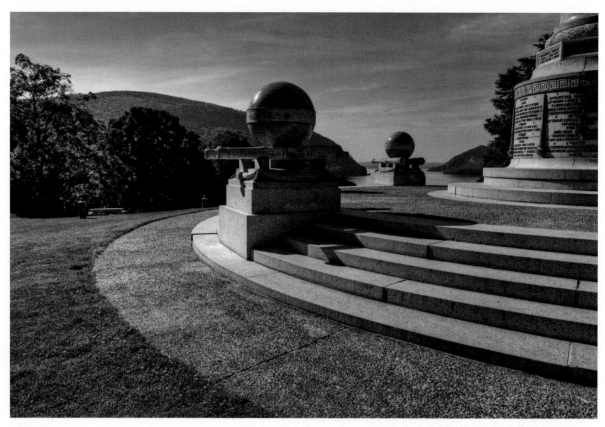

Battle Monument, West Point

polished granite shaft in the Western Hemisphere. The figure at the top, "Lady Fame" or "Victory," was sculpted by Frederick MacMonnies, best known for his sculpture of Nathan Hale in City Park in Manhattan.

Popolopen Creek Suspension Bridge, Bear Mountain Bridge (Fort Montgomery State Historic Site)

The Popolopen Creek Suspension Footbridge (dedicated in 2002 by Governor George Pataki and visible in the foreground) is a walkway for pedestrians only. It connects twin forts—Fort Montgomery on the west side of the Hudson River and Fort Clinton on the east side and is part of the Appalachian Trail. The footbridge is easily accessed through Fort Montgomery, an archaeological site with remains of a 14-acre fortification perched on a cliff, the scene of a major battle for control of the Hudson River during the Revolutionary War.

The Bear Mountain Bridge, 2,257 feet in length, was completed in 1924 and at that time was the longest suspension bridge in the world. Today, it is renowned for its spectacular views.

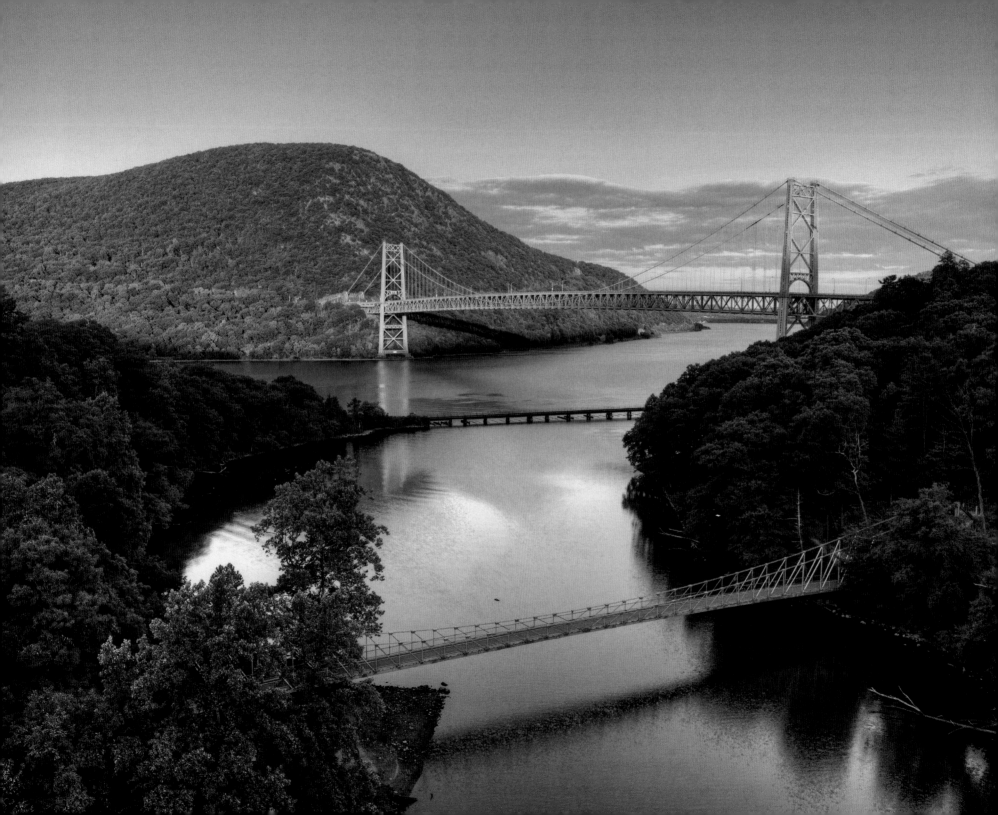

Peekskill

Peekskill is named for Jan Peeck, the first European known to come to the area circa 1650. He lived in New Amsterdam and traveled north by sloop where he traded manufactured goods with the Native Americans in the area. The Peekskill area was named "Peeck's Kill" or Jan Peeck's Creek.

The original white settlers in the mid-seventeenth century were farmers or involved in river transportation and related industries. There were docks, warehouses, and thriving mills there before the American Revolution. Sloops carried grain, leather, and other goods between New York City and Albany.

The years between 1685 and 1776 were a prosperous time for the people and businesses of Peekskill.

And during the Revolutionary War, George Washington established Peekskill as the regional command center due to its strategic location before moving it north to West Point. The city is perched on several small mountains ranging in height from three hundred to six hundred feet, overlooking the Hudson River. The hills are named Mortgage, Chapel, Drum, Fort, Society, and Jacobs. Blue Mountain Reservation, at an elevation of over seven hundred feet, is within the city limits as well.

In 1816 Peekskill was incorporated as a village in the Town of Cortlandt and continued to grow. The era of the railroad helped to bring the town into a vital period of expansion. In the early nineteenth century an iron-casting foundry and stove-making factories began to flourish along with the Annsville Wire Company. By 1850 Peekskill was a major stop on the railroad between Albany and New York City and the village hummed with industries as did other Hudson River communities like Nyack, Ossining, Cold Spring, and Newburgh.

Interestingly, president-elect Abraham Lincoln stopped at the train station and spoke in 1861. There is a marker on South Street commemorating the occasion which overlooks the site of that original railroad depot. Lincoln's stop in Peekskill was his only appearance in Westchester County.

Peekskill was an Underground Railroad stop, and many refugees from slavery were helped to freedom here. The prominent abolitionist Henry Ward Beecher lived in Peekskill for a time.

The village experienced growth in the economy and population after the Civil War. The primary industry was the manufacture of cast iron cooking and heating stoves. There were also lumberyards, boatbuilders, and an array of clothing factories. Most of these industries are long gone, but a few businesses that began in the

Meeting and Market Place Mural (by artists Mariah Fee and Francesca Samsel), Peekskill

South Division Street, Peekskill

1800s are still in business today, including N. Dain's Sons Lumber, J. J. Dorsey Funeral Home, and Arthur Weeks & Son Jewelers.

There are paving stones off Water Street in Peekskill, near Hudson and Central avenues, observed by L. Frank Baum (1856–1919) on his travels to Peekskill by steamboat and train. These stones are reputed to have inspired Baum to invent "the yellow brick road" now renowned from his book *The Wonderful Wizard of Oz*. According to Peekskill city historian John Curran, this tidbit of city trivia has been confirmed by the Oz Society. Some other interesting facts about Peekskill: the New York Jets trained there from 1963 to 1968; and the city is the birthplace of George Pataki, Mel Gibson, Stanley Tucci, and Pee-wee Herman (Paul Reubens).

Like many Hudson River cities, Peekskill experienced a downturn in the 1970s, and its transformation into a community of the arts decades later seemed

Brown Plaza, Peekskill

improbable. The Paramount Center for the Arts was formed in the early 1980s and has grown over the years; there are now dozens of concerts annually with talent like the Beach Boys and Smokey Robinson. Additionally, the Peekskill Business Improvement District was inaugurated in 1995 and started to produce noteworthy special events.

Creative people were attracted to the area's comparatively low rents and proximity to Manhattan. The city began to develop a reputation as an artist-friendly place with civic leaders incorporating the talents of artists into the community. Completion and occupancy of the High Tech Art Loft Complex in 2002 expanded the community of artists who chose to live in Peekskill. These light-filled, duplex art studios would be the envy of any artist, and the public is invited to visit the space during an annual open studio tour. The blending of businesspeople, artists, and government leaders has given a boost to the city's economy. A Collaborative Mural Project has artists working with senior citizens to create enormous works of lasting public art. The murals from these workshops enhance the city's streets and delight visitors.

Visual arts are not the only creative activity thriving in Peekskill. In 2010 HBO filmed a remake of *Mildred Pierce* starring Kate Winslet. The crew transformed sections of Peekskill into 1930s Los Angeles, and several local residents were hired as extras.

The Hudson Valley Center for Contemporary Art opened to the public in 2004. Founded by the Marc and Livia Straus family, it is dedicated to the development and presentation of cutting-edge art. The exhibits and programs also enrich the understanding of contemporary art and its relationship to social issues. Featuring the work of world-renowned artists as well as emerging

Peekskill Fire Bell

talent, the center offers events that attract artists from around the globe to the Hudson Valley. The center is committed to the enrichment of Peekskill, a multicultural community that has reinvented itself in recent years as a regional center for art and culture.

The Flat Iron Building

The upper floors of the Flat Iron Building (circa 1910) on South Division Street consist of artist studios, an art gallery, and exhibit space for local artists. Like the triangular building, the block itself is shaped like a flat iron and housed a Ford dealership in the early twentieth century. Today it is home to the Peekskill Coffee House, a lively meeting place for members of this community in transition.

Paramount Center for the Arts

Originally opened as a 1,500-seat movie palace in 1930 by Publix Pictures and designed as a state-of-the-art facility by George and Charles Rapp, the Peekskill Paramount boasted a Wurlitzer theater organ, enormous air-conditioning capacity, and a beautiful lounge. The building has a neo-classical design and its ceiling is brick and plaster, similar in style to Italian opera houses, decorated with busts of Dante and Caesar. It is listed on both the New York State and National Registers of Historic Places. The theater prospered for decades but with the popularity of shopping malls and television, its audience declined and it was sold in 1973. Due to a tax default, the theater ended up being acquired by the city of Peekskill in 1977. Thanks to a grassroots effort, the "Save the Paramount" campaign led to the establishment of an independent nonprofit corporation. Since

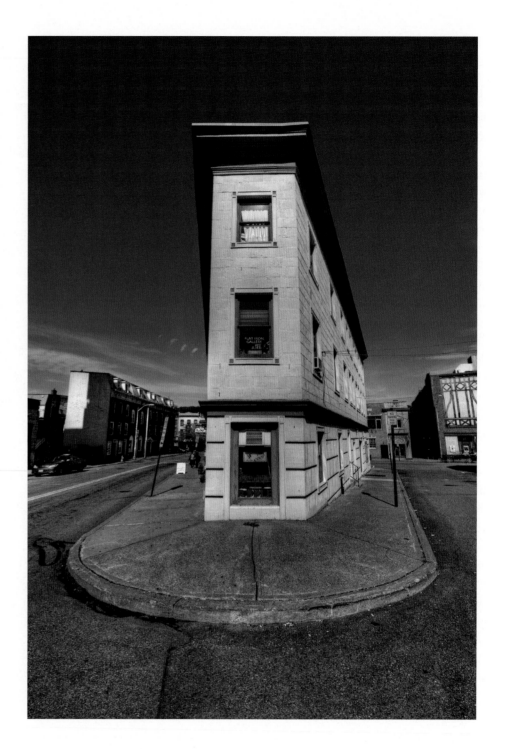

Flat Iron Building, Peekskill

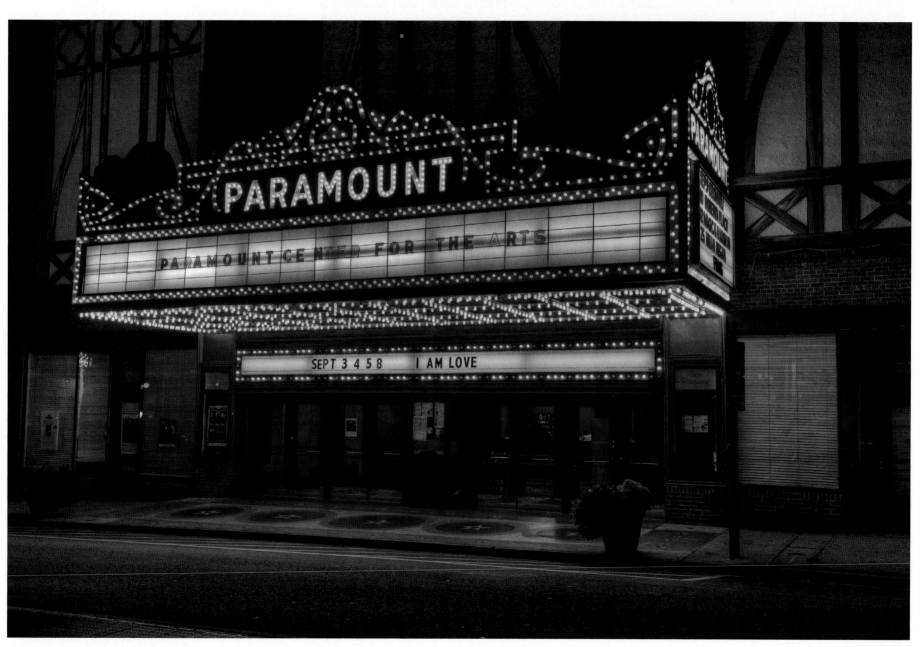

Paramount Center for the Arts, Peekskill

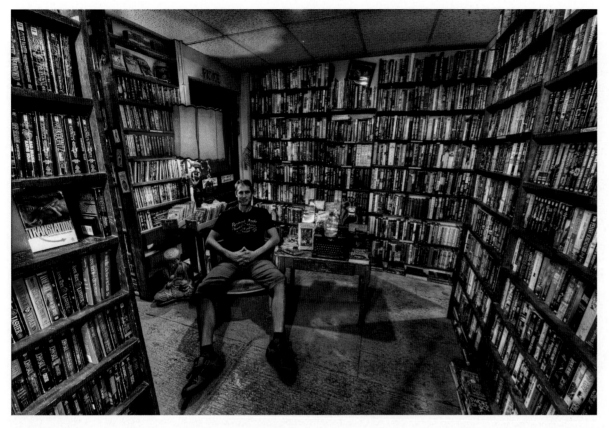

Scott Sailor, proprietor of Bruised Apple Books, Peekskill

1982 the Paramount Center for the Arts has been substantially renovated and offers educational and cultural programs at affordable prices year-round, in addition to concerts with top talent. The theater is a testament to how a city can pull together to create a vital community resource.

Bruised Apple Books

Since 1993 Bruised Apple Books has been buying and selling used, out of print, and rare books and records. More recently, CDs and DVDs have been added to the mix in this eclectic shop with a vintage vibe. Owner Scott Sailor is proud of running a browser's bookstore: cozy seats are scattered throughout 2,000 square feet of space inviting customers to slow down and enjoy. With over 50,000 titles in more than 200 subject categories, something on these shelves is sure to please just about every bibliophile. Adding to the atmosphere are sliding ladders propped against bookshelves, creaky hardwood floors, and the distinctive smell of old tomes permeating the store. There is a decent selection of new books and maps dealing with the art, history, and landmarks of the Hudson Valley. A community gem, Bruised Apple Books is one of the few remaining mom-and-pop bookstores in the Hudson River towns these days.

Standard Brands / Fleischmann's Yeast

Fleischmann's Yeast, also known as Standard Brands, operated in Peekskill from 1900 to 1977. For a time it was the largest yeast-making facility in the world and the company reminded consumers: "It's Fleischmann's yeast that raises the nation's bread."

A 1915 company press release stated, "Peekskill-on-the-Hudson is a beautiful advantageous location." At that time, there were more than 125 buildings spread out over one hundred acres. Five thousand bushels of grain, corn, rye, and barley were processed there every day.

Although the company changed its name to Standard Brands in 1929, locals still called it Fleischmann's. Over 1000 people worked at the plant at one time, including Governor George Pataki, who recalls working in the Gin Building, now the Crystal Bay Restaurant.

Molasses is the base of yeast and the thick dark liquid is put through several processes before becoming the food that helps yeast grow. Molasses arrived on huge ships that were unable to dock and unload, so molasses was put on barges and brought to shore. The molasses had to be kept heated during this transfer and it was an expensive ordeal. Finally in 1938 a pier was built and a channel was dug into the Hudson to accommodate the ships. The pier was unusually long and narrow, specially designed to unload molasses.

Pieces salvaged from the one foot in diameter pipe that formerly carried the molasses from the ships now make up a sculpture that stands near the pier's entrance. When it was restored in the 1980s, the pier was named China Pier to pay tribute to the role of the Hudson River as an engine of global commerce. However, in 2010

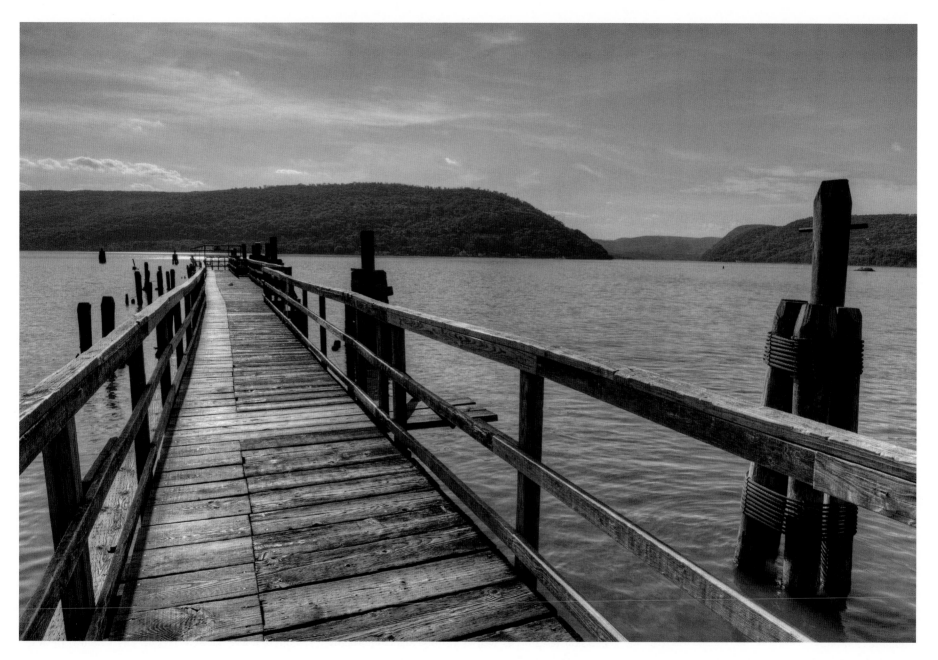

Fleischmann Pier, Peekskill

Peekskill Brewery

The Peekskill Brewery, formerly a car garage by the city's Riverfront Green, was transformed into a contemporary pub/microbrewery in 2008. While serving up its own creative and seasonal brews, this casual spot also offers over a dozen draughts and about one hundred bottles from the finest craft breweries . . . as well as hearty fare. Such a lively establishment is a welcome addition to the community, a delightful part of its ongoing renaissance.

Indian Point Nuclear Power Plant

There is no way travelers along the lower Hudson River by air, car, or water can miss the two distinctive concrete domes along the shoreline that are part of the Indian Point Nuclear Power Plant just south of Peekskill in Buchanan. It was 1962 when the first reactor began operating. Since 1970 Indian Point has provided residents of Manhattan and Westchester County with almost one-third of their electricity; it is owned and operated by the Entergy Corporation.

In recent years there have been tritium leaks, a defective siren system, and inadequate emergency evacuation plans for the surrounding communities in the event of a major catastrophe. These problems have resulted in Indian Point being included on the federal list of the nation's worst nuclear power plants.

The New York State Department of Environmental Conservation ruled that the plant's obsolete cooling system, which draws out and then pumps back as much as 2.5 billion gallons of heated water into the Hudson River daily, violates the federal Clean Water Act. Millions of fish are killed as a result. The plant uses the water

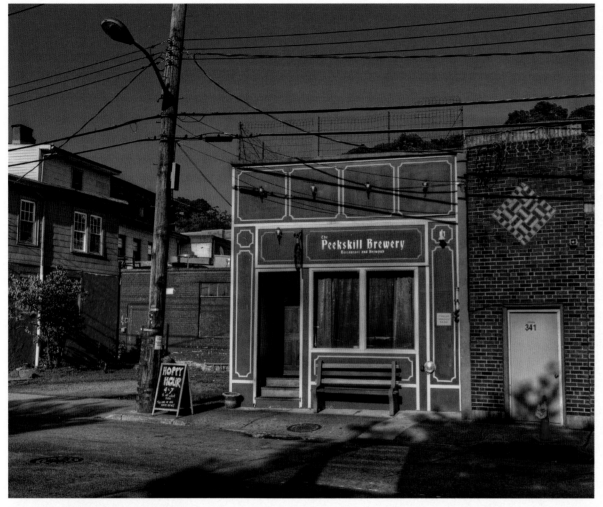

Peekskill Brewery

it was renamed Fleischmann Pier, to acknowledge an important American industry and a huge resource for the city of Peekskill. It is one of very few deepwater piers along the Hudson.

Today most of the Fleischmann buildings are gone, but the pier still stands. It is one of the better fishing spots on the Hudson River and offers great views.

Only a short time ago, Charles Point Park was a dumping ground and Fleischmann Pier was at risk of decay and collapse. Now the area is a recreational resource for Peekskill residents as well as visitors. Standard Brands "raised the nation's bread," and the revitalization of this area will raise the spirits of anyone who ventures out on the pier that Fleischmann's built.

Indian Point Nuclear Power Plant, Buchanan, right

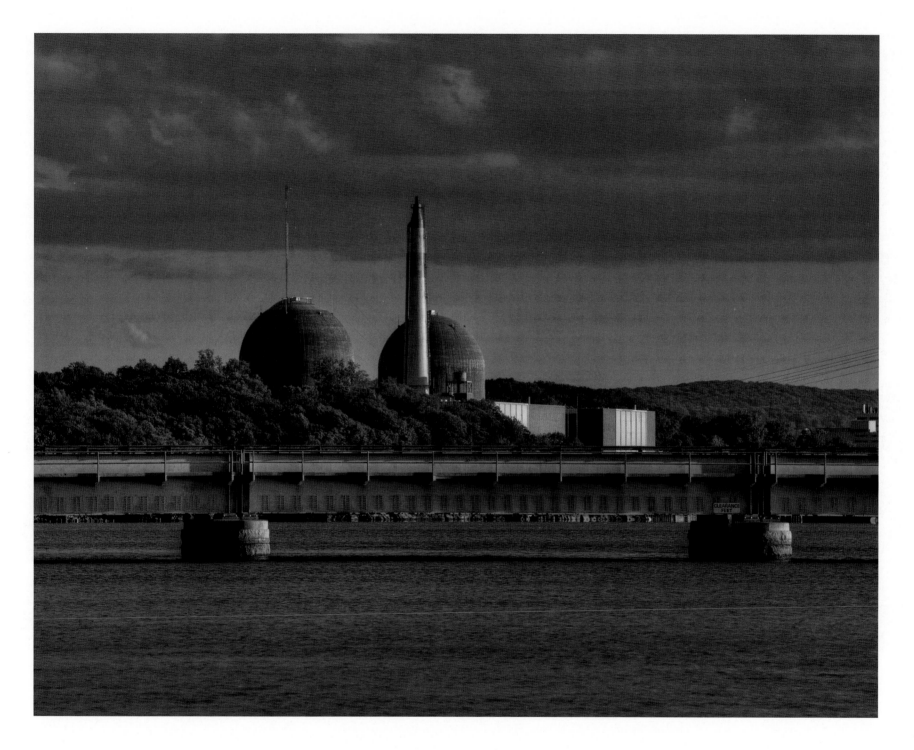

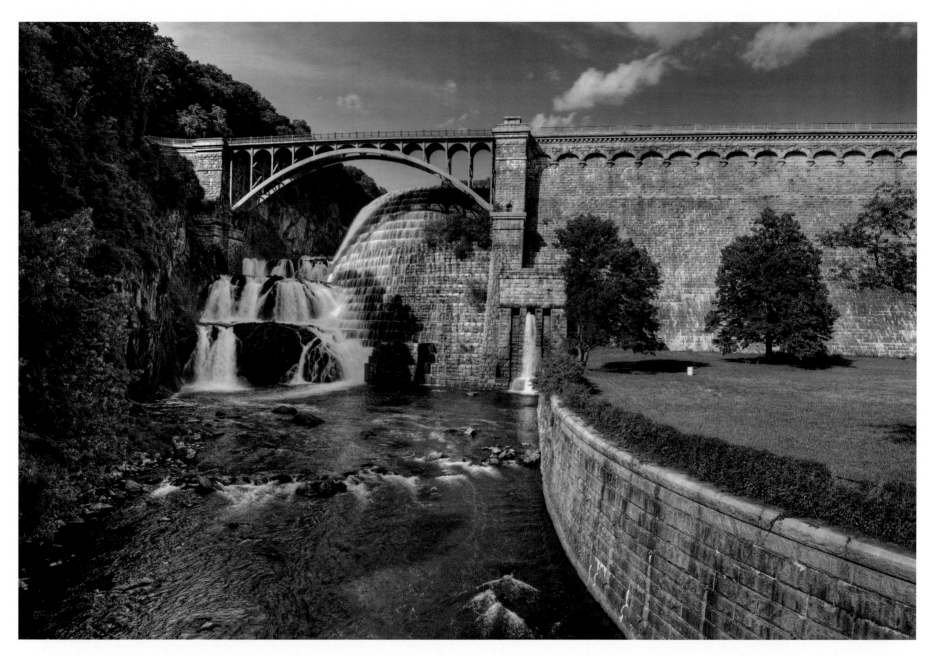

New Croton Dam, Croton Gorge Park

to cool the machinery that turns uranium into electricity. When the heated water is returned to the river, this process, known as thermal pollution, harms aquatic life in the Hudson.

Closing the plant, however, would put a huge strain on the region's power grid. And without a water-use permit from the DEC, Indian Point cannot have its license renewed by the Nuclear Regulatory Commission for another twenty years and would have to cease operations in 2015. The battle to protect the delicate ecosystem of the Hudson River is being fought by Riverkeeper and other environmental groups. At the same time, the demand for electricity is increasing throughout the region. And so the struggle continues. The DEC suggests a closed-cycle cooling process that would require less water by reusing much of it. Solutions to the dilemma under consideration are the construction of an underwater filtering system as well as the building of cooling towers so that wastewater is not discharged into the Hudson River.

Croton Aqueducts

The Old Croton Aqueduct supplied water to New York City from 1842 to 1955. The aqueduct began at the original Croton Dam and ended in two reservoirs forty-one miles away—one at the site of the Great Lawn in Central Park and the other at the New York Public Library at 42nd Street. The construction was begun in response to epidemics and fires that continually plagued New York City due to its inadequate water supply and contaminated wells.

Designed by John B. Jervis on principles dating back to Roman times, the enormous gravity-fed tube dropped thirteen inches per mile, an engineering marvel when work began in 1837. Until 1955 this aqueduct brought water to Manhattan. However, the supply was insufficient due to the city's burgeoning population. The

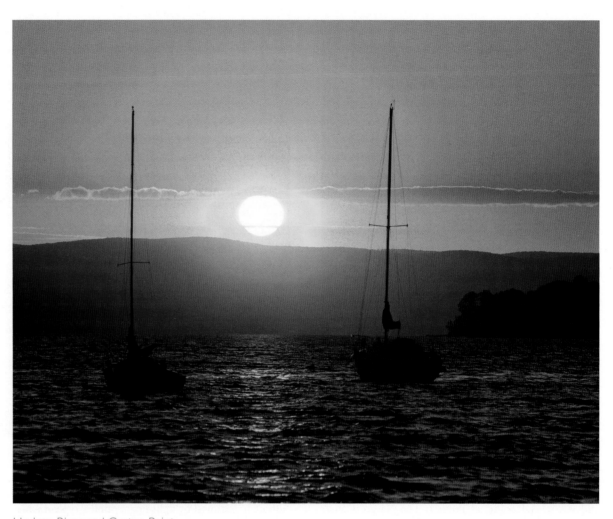

Hudson River and Croton Point

New Croton Aqueduct, triple the size and deeper underground, replaced the old one. The New Croton Dam was completed in 1907 and is over two hundred feet high.

Croton Gorge Park

The 97-acre Croton Gorge Park is at the base of the New Croton Dam and offers trail access to the Old Croton

Aqueduct. The county park is a popular place for fishing, hiking, and picnicking in the summer months and cross-country skiing and sledding during the winter.

Croton Point Park

The 504-acre Croton Point Park is located on the largest peninsula of the Hudson River (in Croton-on-Hudson)

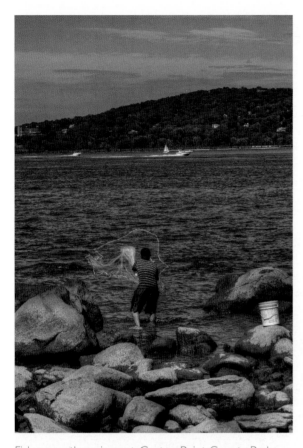

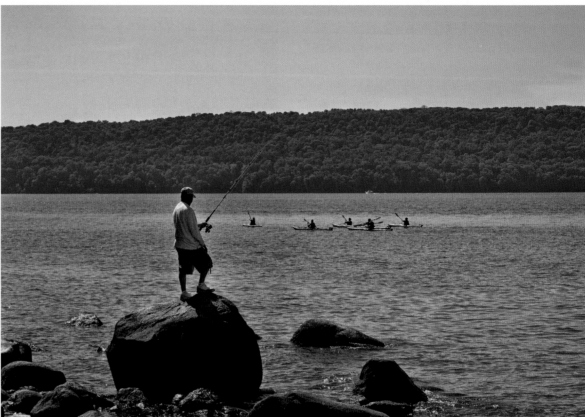

Fisherman throwing net, Croton Point County Park

Fisherman, Croton Point County Park

and has several points of interest. The Nature Center offers year-round programs and has displays of local flora, fauna, and archaeology. A Discovery Trail takes visitors through the park and allows them to explore the native plants and wildlife, including painted turtles and several varieties of frogs.

Those who wander through the park may come upon the Treaty Oak Monument, which commemorates the peace treaty signed in 1645 between the Dutch and the Kitchawank Indian tribe, the area's first residents. The treaty was signed under a huge white oak tree.

Although destroyed by lightning, a similar type of white oak was planted years later in its place. There is a 113-acre meadow in the park, atop a hill, an excellent place to watch birds, including bald eagles. The southern tip of Croton Point, Tellers Point, was named for the family that owned a trading post there in the mid-seventeenth century. There are fantastic views both up and down the Hudson from this spot; it's an excellent place to watch the plentiful osprey. On the south side of the park is Croton Bay, an ideal habitat for striped bass, perch, and eel, with its tidal marshes and unique wildlife including

great blue herons. At low tide the shoreline is filled with driftwood.

In the 1830s, the area was home to the Underhill Brick Making Company and traces of brick may be found today in the park. There were vineyards and fruit grown by an earlier generation of the Underhill family, who also operated a gristmill on the Hudson. The historic vaults used as wine cellars are all that remain of the winery. They are believed to be some of the oldest wine cellars in America and once held 30,000 gallons of wine.

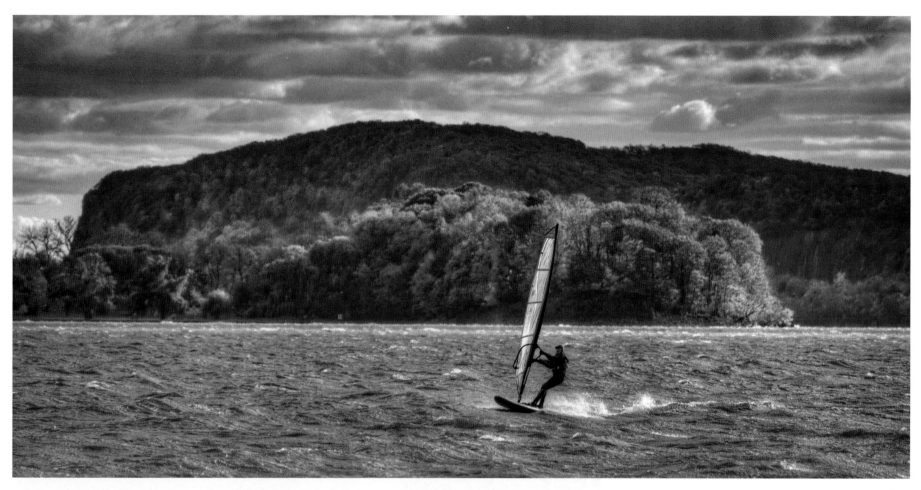

Windsurfer off Croton Point Park

Croton Point has been owned by Westchester County since 1924. It may be difficult to believe when surveying this incredibly scenic area, but for a time the park was used as a county landfill. Today, Croton Point is a magnificent park surrounded on three sides by bays of the Hudson River.

Since the mid-1960s Croton Point Park has been the site of the annual Clearwater Festival, later named the Great Hudson River Revival. The proceeds from this weekend concert in June go to the Hudson River sloop *Clearwater*, a nonprofit environmental group. Pete Seeger, folk-singing legend and the festival's founder, created this musical gathering and it has grown over the decades and become an annual Father's Day weekend tradition.

Croton-on-Hudson

First inhabited by the Kitchawank Indians, Croton is believed to be named for a chief of that tribe, Kenoten, whose name means "wild wind"; Croton-on-Hudson was incorporated as a village in 1898. In 1932, two separate communities—Mount Airy and Harmon—were incorporated into the village. Both communities had a distinctive identity. Mount Airy had been a Quaker enclave into the 1800s but evolved in the early 1900s into a summer arts colony that attracted Greenwich Village writers and artists. The poet Edna St. Vincent

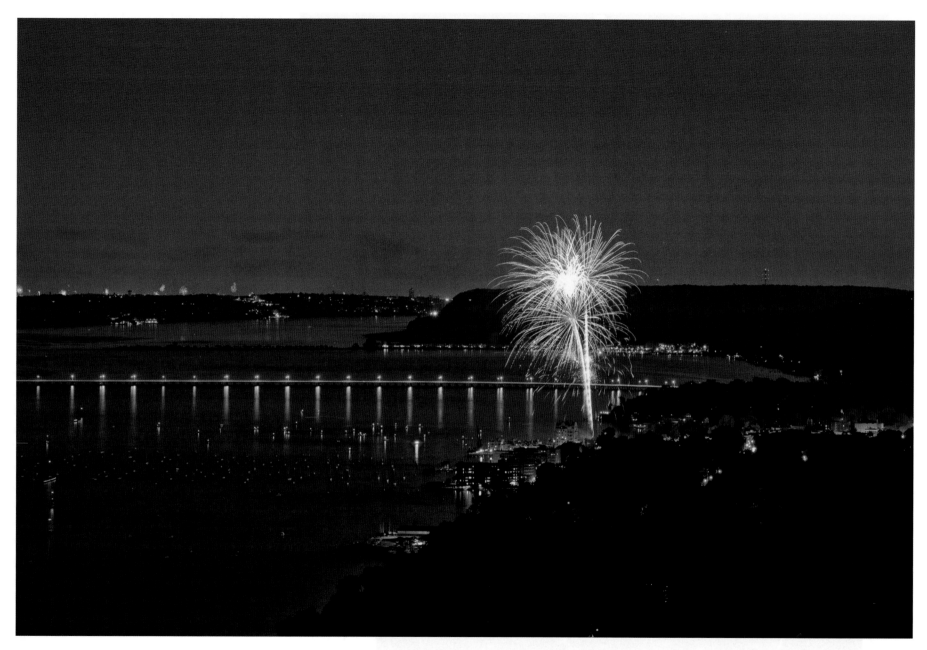

Fireworks over Nyack and Piermont, Hook Mountain views

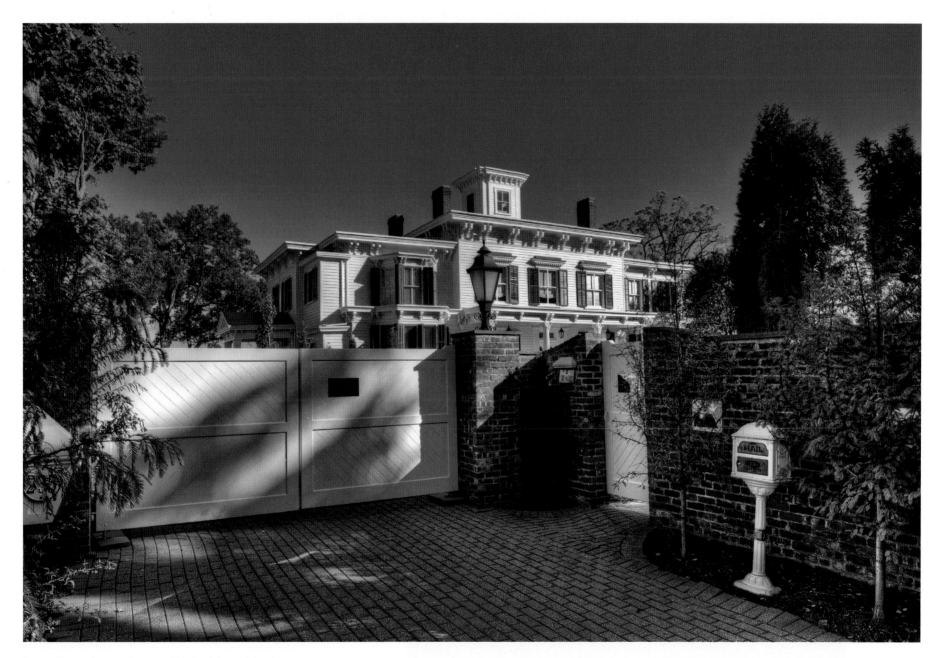

Pretty Penny, former home of Helen Hayes, Nyack

Nyack is known as an arts center today, home to dozens of shops that offer fine furniture, antiques, and crafts. The town's charming architecture, river location, and fine restaurants make it a popular tourist destination. Many highlights of the village are best observed on foot. A walking tour reveals the Nyack Public Library, built with funds from the Carnegie Foundation at the turn of the twentieth century. On Broadway is Couch Court, an unusual late-nineteenth-century building with a tower-like cupola. On North Broadway is Congregation of the Sons of Israel, a synagogue founded in 1870 along with stunning mansions and beautiful eighteenth-century homes.

The annual Mostly Music concert series is a treat for both summer residents and visitors. And during the Art Walk, stores in town are turned into mini–art galleries with artists who are delighted to talk with the public about their work. Nyack's Famous Street Fair on Main Street is an annual October tradition drawing thousands of people and featuring over two hundred exhibitors. Jewelry, fiber arts, pottery, photography, antiques, and collectibles are just some of the items for sale. Dozens of food vendors are on hand and there are special children's activities. The fair is free and open to all; it's held rain or shine.

While the major boatbuilding businesses and sawmills have long disappeared, Nyack has earned a reputation as a charming place where the arts flourish. Travelers are always welcome to explore its rich architecture and culture—both past and present.

Piermont

Many people in the metropolitan New York area were made aware of the existence of Piermont with the release of Woody Allen's film *The Purple Rose of Cairo* (1985),

Nyack Community Gardens, Franklin Street

Village Vintner, Nyack

British ships showered the house with cannonballs; in later years, residents dug them out of the front lawn. Some are still in the possession of former owners of the house.

The place known as Piermont was developed in the 1830s when the New York and Erie Railroad was chartered by the state in 1832 and built a rail line from the Hudson River to Lake Erie. The Slote was chosen as the eastern terminus since it was the last port before the New Jersey border. Laborers arrived in droves and cut down rock from the hillsides to create ninety new acres of land including a long pier extending almost a mile out into the Hudson. In 1839 the village was renamed Piermont, a reference to this new construction.

The railroad was operational in the mid-nineteenth century and a brass factory, sawmill, and lumberyard thrived in town as well. The heyday of the railroad was short-lived, however. Erie moved its main terminus from Piermont to Jersey City in 1852, leaving only a commuter railroad depot. Piermont's population went into decline and shops closed.

The fact that Piermont was so close to Manhattan led to an old mansion being converted into a hotel, the Fort Comfort Inn. This resort attracted tourists and with easy access to the waterfront, Piermont became a popular vacation destination. In 1902 the Piermont Paper Company arrived with a few other related industries. By the 1980s, however, economic and environmental issues rendered these businesses unprofitable and the properties were sold.

Today elegant housing at Piermont Landing and the town library occupy land originally developed by the Erie Railroad nearly two centuries ago. The town's lovely waterfront setting still attracts visitors to the village.

Interestingly, there are no cemeteries in the village. There used to be one under the rear part of the village hall—the old burial ground of the Salem

since it was shot in the village. The main street, Piermont Avenue, underwent a complete transformation to be used as a movie set. Piermont is a charming place that has retained its small town ambiance. Piermont Avenue is filled with interesting shops and galleries and it's only a short walk to the waterfront. But Piermont's history was greatly determined by its geography—and it had its ups and downs.

Millions of years ago geological events left a break in the rock wall of the Palisades on the western shore of the Hudson River. The break and the creek that ran through it to the Hudson created a passageway to the interior of the region, making an ideal place for trade to develop.

The Tappan Indians inhabited the area and traded with Dutch settlers when they began arriving in the seventeenth century. The place was called Tappan Slote (*slote* means "ditch" in Dutch) and Tappan Landing, as well as the Slote. The name Piermont came much later. There were plentiful fish and game that sustained the settlers whose trade and travel was dependent upon sloops.

During the Revolutionary War period, the River Road (now Piermont Avenue) was originally a horse trail used to move troops and supplies. The town's Onderdonk House, listed on the National Register of Historic Places, was the home of ardent patriots.

Turning Point Café, Main Street, Piermont, above

Main Street Fair, Nyack, left

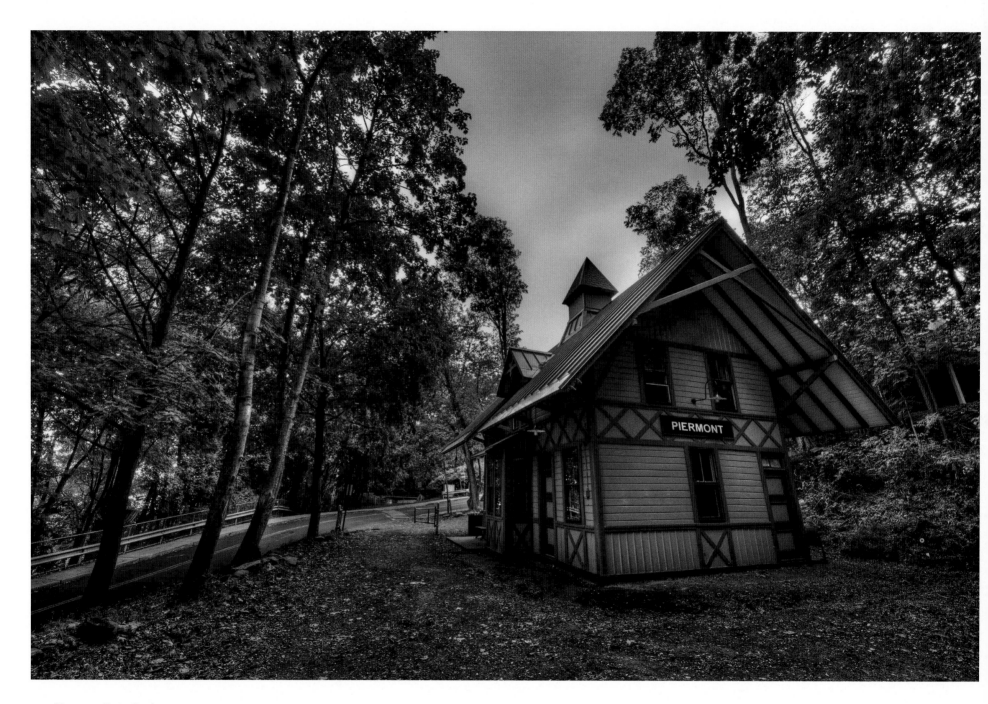

Piermont Train Station

Baptist Church. When the church was torn down in 1937, the bodies of its parishioners were reburied up the hill beyond the village hall. After several years, the tombstones were removed and neighbors planted gardens there.

The Mysterious Mine Hole

There are a few theories about the origins of the Mine Hole, Piermont's famous cavern on South Piermont Avenue. Some people think it may have been dug in search of precious metals like iron pyrite (Fool's Gold) or fine rock for a millstone. The book *Piermont: Three Centuries*, published by the Friends of the Piermont Library in 1996, describes an old mine hole cut in the rock above the north bank of the Sparkill Creek and offers a theory that dates back to the late eighteenth century: "A local inhabitant, John Moore, operated a mill on the creek and needed grinding stones for his mill. He found just what he was looking for on the nearby hillside and began to hack away, creating first a cave and then a mine. It was said the walls of Moore's mine were as smooth as glass, and that he continued getting his millstones from the mine site until the early 1800s."

John Moore was an enterprising free black man who purchased property in Piermont. In addition to his sawmill and gristmill, he built a woolen carding mill and employed three men. There was once a thriving black community along South Piermont Avenue known as Mine Hole. In fact, Leonard C. Cooke recalls growing up in that area during the 1920s and 1930s in his book *True Stories from Mine Hole*.

It isn't surprising that Piermont was once a station stop on the Underground Railroad.

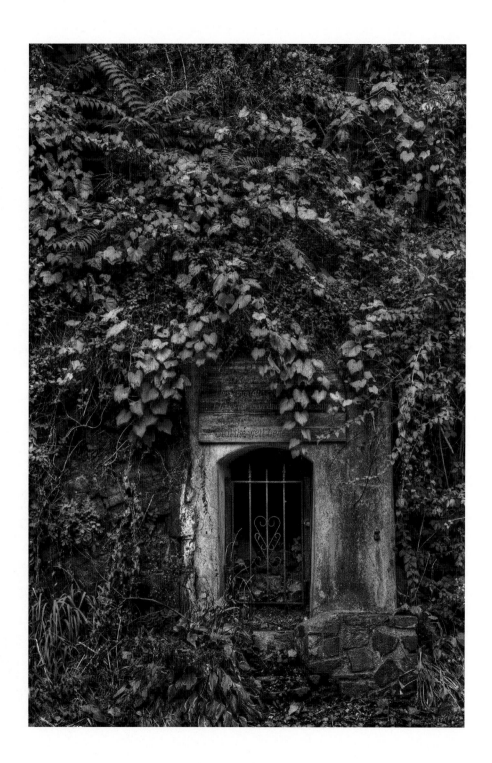

The Mine Hole, Piermont

The Drawbridge

Piermont's hand-cranked drawbridge, originally built in 1880 by a Cleveland, Ohio company that specialized in bridge construction, is one of only a few such bridges remaining in America today. Fishermen on sloops would get out of their vessels, crank up the bridge, sail across the creek and then crank it down for vehicular traffic. Today the drawbridge is used as a pedestrian walkway linking the village of Piermont with Tallman Mountain State Park.

Views to New York City from Piermont Pier

The 4,000-foot-long Piermont Pier extending into the Hudson River was opened by the Erie Railroad in 1838 and is still a popular place to promenade. On a clear day, one can stand on the pier and see the George Washington Bridge and Manhattan skyline.

Tarrytown Lighthouse—Sleepy Hollow (North Tarrytown)

For several decades, sloops and steamboats traveling the Hudson River were threatened by dangerous shoals in the horseshoe-shaped Tarrytown Bay. As a result of this ongoing problem, Congress authorized the building of a lighthouse in 1847, but it wasn't until 1882 that the lighthouse finally opened. It took several years for the exact site to be decided upon—offshore from Kingsland Point in North Tarrytown (Sleepy Hollow)—but it was still known as the Tarrytown Lighthouse.

Due to its shape, the 56-foot-tall structure is known as a "sparkplug lighthouse"; with its three-story

Hand cranked drawbridge, above right

Northern Views, Piermont Pier, below right

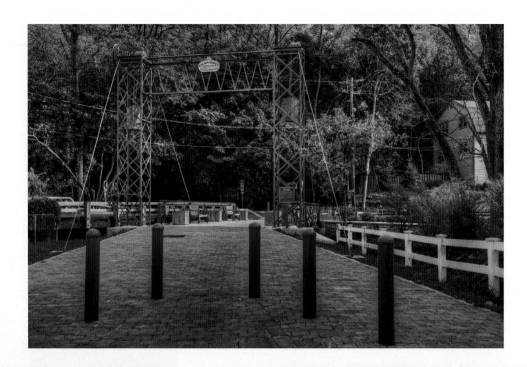

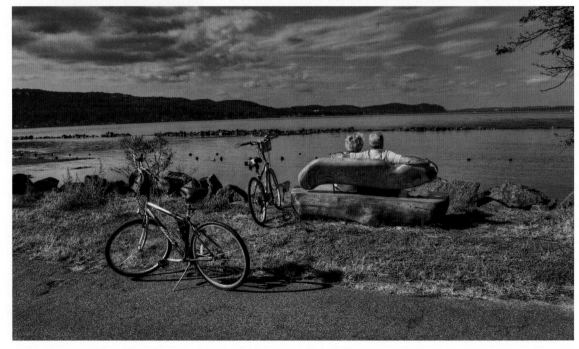

Southern Views, Piermont Pier

lens was removed and the lighthouse was completely deactivated in 1961. The fog bell remains on the upper gallery deck as well as the large smokestack installed when the heating system was converted from a small stove on the first floor to a basement furnace.

In 1979 the Tarrytown Lighthouse was added to the National Register of Historic Places. It is open to the public and there is access through Kingsland Point Park in Sleepy Hollow via a short footbridge. The views are spectacular!

Tarrytown

Tarrytown's riverfront location, its renowned heritage, and its tradition of community diversity are a few of the assets of this magical area that have drawn people to settle there for centuries. In addition to its history and legends, the Tarrytown area boasts acres of preserved parklands, magnificent estates, and phenomenal sunsets.

The first residence built by white settlers in Tarrytown was constructed in 1645, although the exact location isn't clear. The major occupations at the time were farming, fur trapping, and fishing. The soil in Tarrytown was light and loamy, an excellent consistency for growing grain, especially wheat. This fact led to the area being known as Tarwe Dorp (Wheat Town in Dutch); later it was Anglicized to Tarwentown, then Tarrytown.

In his renowned tale, "The Legend of Sleepy Hollow," Washington Irving has a different interpretation for the town's name. He explains the housewives in neighboring areas complained about their husbands hanging out in the village tavern drinking on market days, "tarrying" too long away from home. Tarrytown came to be known as Sleepy Hollow Country due to the writings of Irving, and there are dozens of references to this throughout the town.

In 1655 Adriaen van der Donck, a Dutch colonist,

living area and lantern on top it resembles a spark plug. The lighthouse was prefabricated by the G. W. & F. Smith Iron Company in Boston and assembled on site. The bricks that line the walls of the three landings were made across the Hudson River in Haverstraw. It sits on a cast iron caisson sunk into the riverbed and is surrounded by a stone pier.

There were several keepers at the Tarrytown Lighthouse, but Coast Guard keeper Richard Moreland was the only one who actually lived there with his wife and two children in the mid-1950s. It may have been fun to fish off the pier but less convenient to row a half-mile into shore for groceries and other supplies!

The completion of the Tappan Zee Bridge in the late 1950s included navigational lights, hence a full-time lighthouse keeper was no longer necessary. The Fresnel

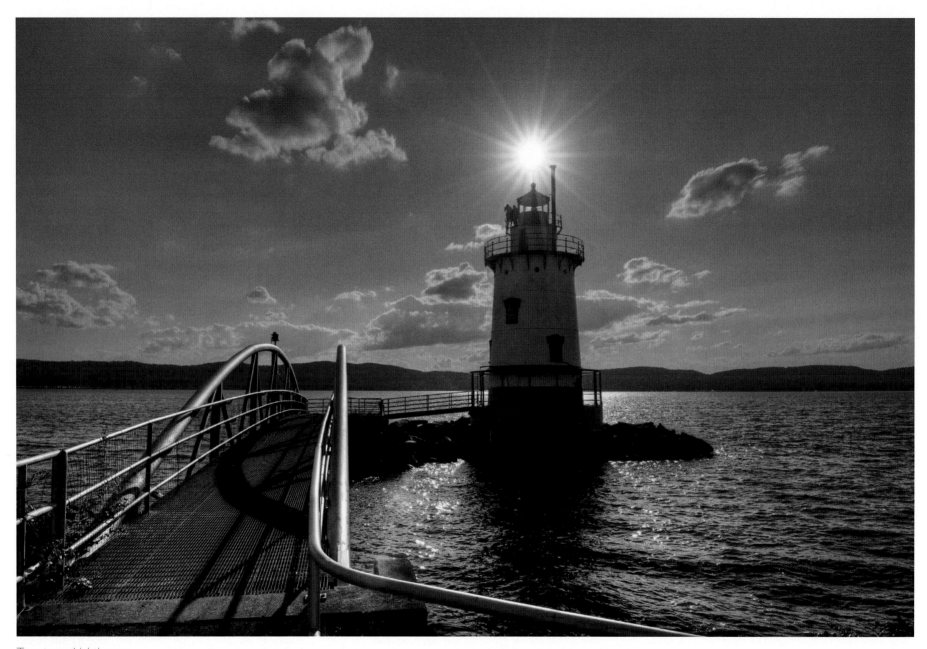

Tarrytown Lighthouse

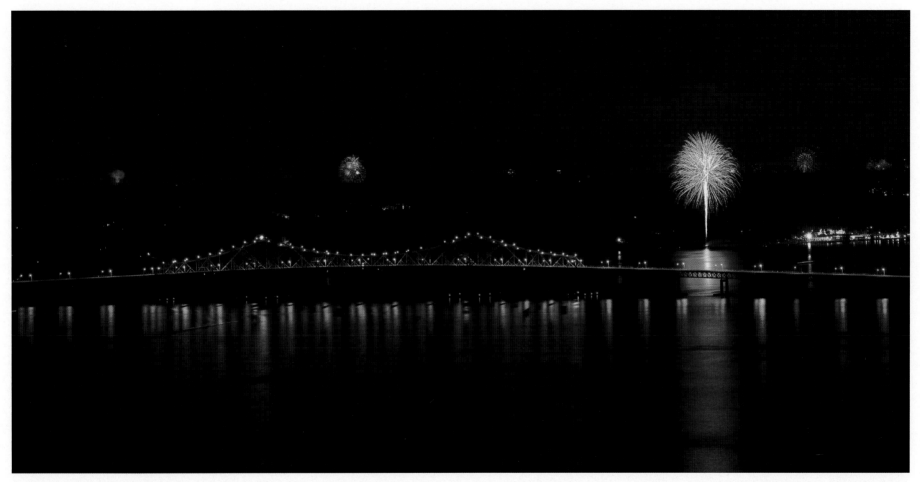

Fireworks and Tappan Zee Bridge

first published a work that referred to the Pocantico River as Slapershaven or Sleepers' Haven. Sleepy Hollow is a later Anglicized version of this name, which eventually became the name of the two-mile-square incorporated village just north of Tarrytown.

The largest area landowner in the late seventeenth century was Frederick Philipse. He owned well over 50,000 acres in what is now Westchester County and built a home and gristmill in Sleepy Hollow. He also built the Old Dutch Church. Tarrytown mostly grew

wheat and there were some small shops in the village. But by the mid-nineteenth century a wagon and carriage factory arrived in town followed by the Silver Shoe Factory in 1871. Within a short period of time there was a cider mill, flourmill, silk factory, boatyard, and other businesses.

The Tarrytown Music Hall was built in 1885 by William Wallace, a chocolate manufacturer, in the Queen Anne style. Originally a venue for opera and vaudeville, it is one of the oldest theaters in Westchester County and

has been used for town meetings as well as an entertainment venue. (President Theodore Roosevelt once spoke on its stage.) The Music Hall still attracts top talent, and Joan Baez, Tony Bennett, and Wynton Marsalis are just a few of the entertainers who have performed there.

In 1899 Mobile Company of USA began manufacturing Walter Steamers in Tarrytown, thus introducing the car industry. The Chevrolet Motor Company followed in 1915: it became General Motors in 1918, opening their business in North Tarrytown (Sleepy

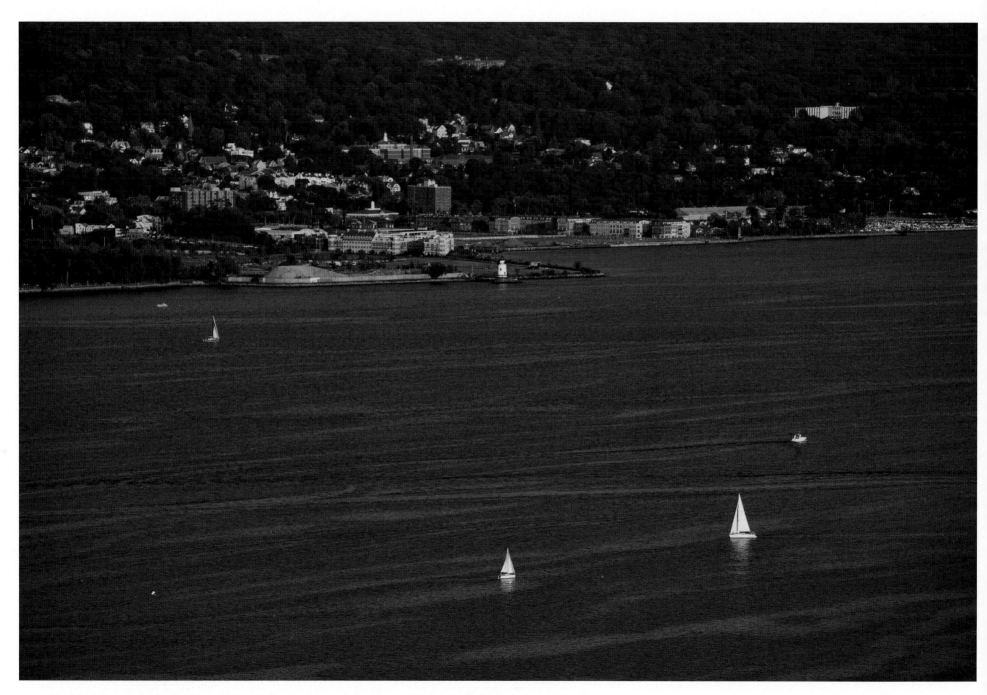

Sleepy Hollow waterfront

Hollow). Before the 1970s most of the workers were local residents. After that time, people began commuting from surrounding counties. Other industries in Tarrytown include General Foods (Kraft General Foods) and Hitachi. Several biotech and high-tech corporations have located in town in recent years and enjoy proximity to the metropolitan area as well as the suburban setting.

At the turn of the twentieth century Tarrytown was known as Millionaire's Colony because of its numerous castle mansions. There were over sixty-five opulent estates at that time. These residents contributed to the economy of Tarrytown by employing local tradespeople and patronizing businesses in town. Tarrytown has been home to several tycoons, including William E. Dodge, merchant and philanthropist; J. D. Maxwell, automobile pioneer; several members of the Lehman banking family, as well as the Rockefellers. Samuel L. Clemens (Mark Twain) also owned a house in Tarrytown. In 1902 he remarked, "Tarrytown has a lower death rate and higher tax rate than any place on the civilized globe."

The opening of the Tappan Zee Bridge in 1955 was a watershed year for Tarrytown, prompting development of office parks and hotels, and generating new tax dollars. But it also caused traffic problems along Route 9, the main thoroughfare, also known as Broadway, that persist today.

Kykuit, the Rockefeller Estate

This six-story neoclassical stone house, nearly a century old, was the home of four generations of the Rockefeller family. John D. Rockefeller, founder of Standard Oil and the richest person in America in his time, hired architects Delano and Aldrich to build a home for his family.

Kykuit Estate, Sleepy Hollow

Kykuit (a word of Dutch origin meaning lookout or high point) was built between 1906 and 1913. Today the estate is open to the public and is operated by the National Trust for Historic Preservation. The Big House, as the Rockefeller family called the main residence, is filled with Chinese and European antiques, ceramics, fine furnishings, and artwork.

There are several outbuildings, including the Coach Barn with its collections of horse-drawn carriages and vintage cars. In addition, there is the *orangerie* and Playhouse, a Tudor-style mansion with indoor swimming pool, tennis court, gym, and bowling alley. Landscape architect William Welles Bosworth designed the beautiful terraces and gardens with fountains and pavilions. The sculpture collection of several generations of Rockefellers adorns the gardens and includes works by Pablo Picasso, Henry Moore, Alexander Calder, and many other renowned artists. The gardens, artwork, and scenery conspire to make Kykuit a rare jewel; it is one of the finest and

Knife Edge, Kykuit (artist: Henry Moore)

best-preserved Beaux Arts homes in America. The country residence of one of America's most distinguished families, Kykuit shows the distinctive touch of each generation who has lived there.

Old Dutch Church and Burial Grounds

The Old Dutch Church of Sleepy Hollow was constructed in 1685 on what was the manor of Frederick Philipse. One of the oldest churches in New York State, this stout stone building is still used, albeit occasionally, for services. Washington Irving's "The Legend of Sleepy Hollow" has made the church and burial ground world famous. (The burial ground where Ichabod Crane sought refuge is the yard of the Old Dutch Church, not the adjacent Sleepy Hollow Cemetery, which didn't exist when Irving wrote his tale.) In "The Legend of Sleepy Hollow," the

Adam and Eve, Kykuit (artist: George Gray Bernard)

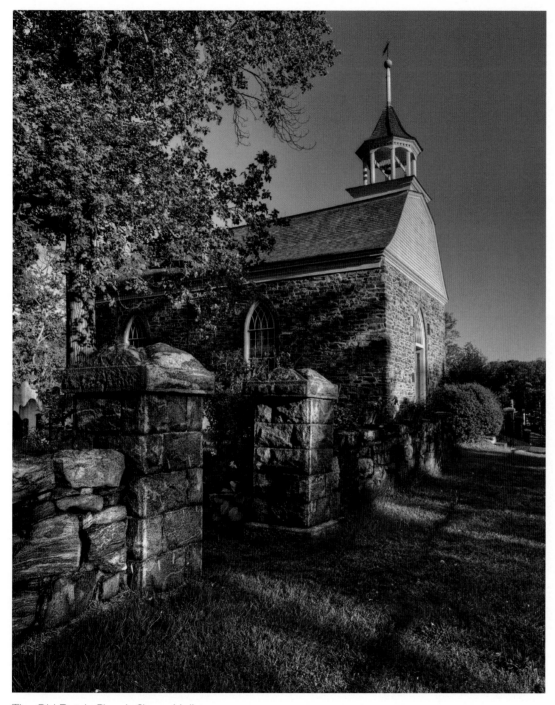

burial ground is the haunt of a certain headless Hessian, as well as the resting place of local citizens who probably inspired Irving's characters of Katrina Van Tassel and Brom Bones. The Old Dutch burial ground is where Washington Irving's grave may be found . . . and the Sleepy Hollow Cemetery is the resting place of Andrew Carnegie, Walter Chrysler, and some members of the Rockefeller family.

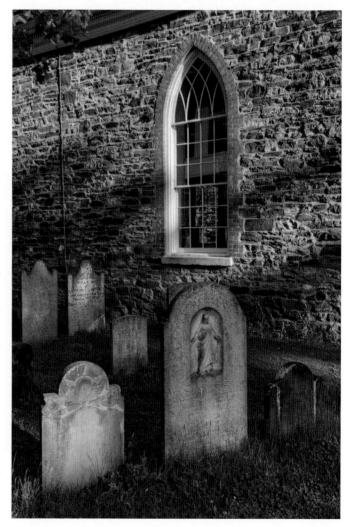

The Old Dutch Church, Sleepy Hollow

Headstones, Old Dutch Church burial ground

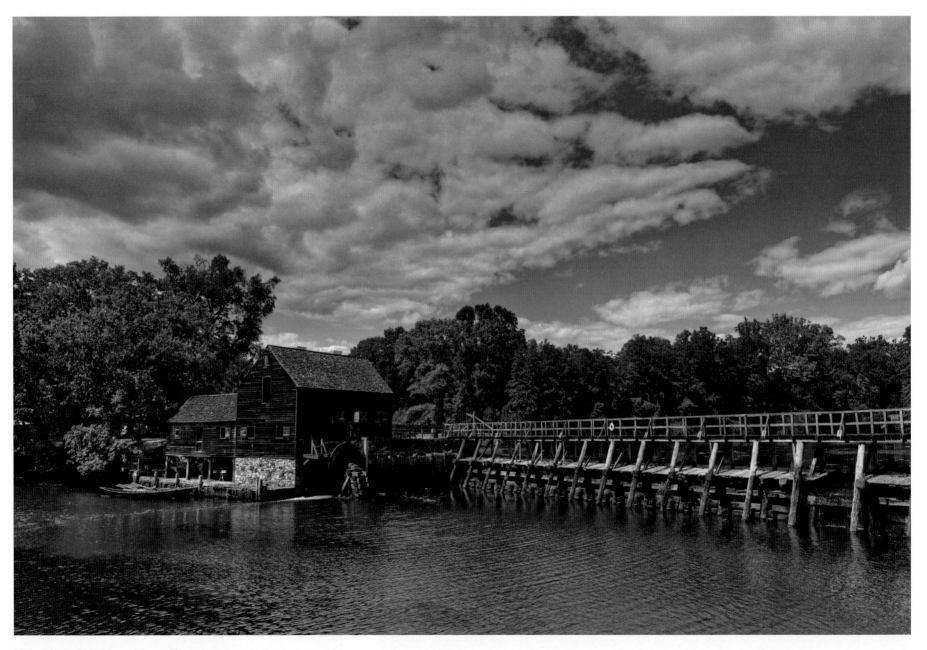

Upper Mills, Philipsburg Manor, Tarrytown

Philipsburg Manor

Once the centerpiece of a seventeenth-century estate of more than 50,000 acres, Philipsburg Manor was founded by Frederick Philipse, an immigrant carpenter from Holland. The manor was part of a busy commercial empire with large milling and trading enterprises as well as nearly two dozen slaves. For nearly a century the Philipse family were respected colonists, but when the Revolution heated up the family fled to England as Loyalists and their landholdings were split up.

The mill, still run by waterpower, continues to grind meal and turns out nearly 1,000 pounds of flour every year. Most of it is purchased by visitors to the manor, now a National Historic Landmark and museum.

Costumed guides involved in the business of working on a farm often recreate scenes of life at the time. Some of these dramatic vignettes show how an estate in the North also depended on slavery for economic survival. On one visit to Philipsburg Manor, I witnessed a conversation where a slave woman seeks permission to visit a family member who had been sold elsewhere. The reenactment of a probable situation at the time demonstrates some of the complex relationships that existed at the manor and shows how negotiations might have occurred centuries ago. Frederick Philipse was engaged in the slave trade, importing small groups from the West Indies and Angola. Some of these enslaved people were sold in other colonies and some worked for the Philipse family on the manor. Interestingly, this historic site has chosen a progressive approach to colonial history and hasn't shied away from some of the less attractive, yet realistic, aspects of early American culture.

Lavada Mahon, slave garden, Philipsburg Manor, Tarrytown

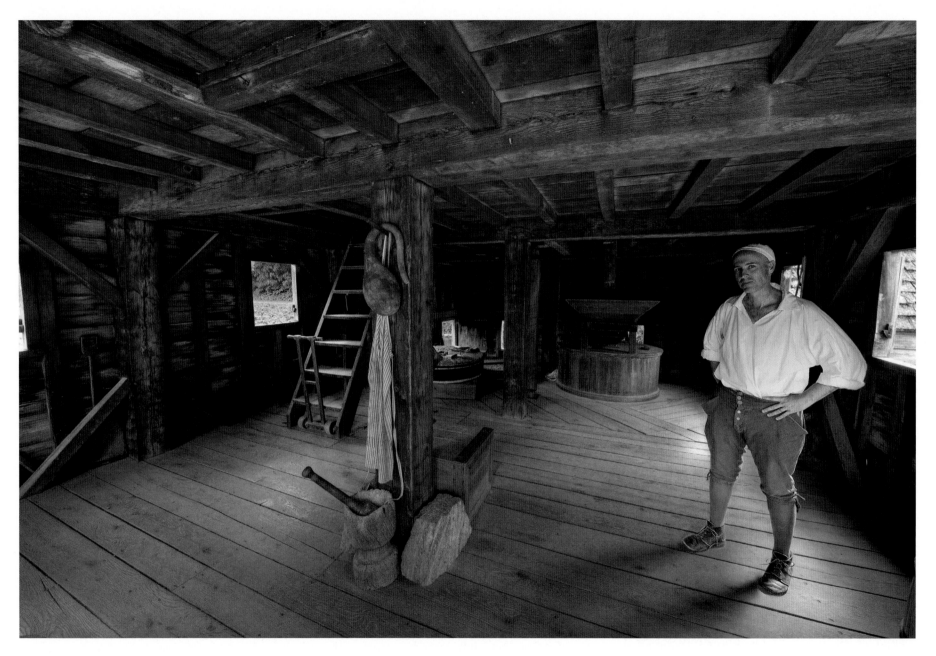

John Page, Head Miller, Philipsburg Manor, Tarrytown

Tappan Zee Bridge

The 16,000-foot-long Tappan Zee Bridge was completed in 1955 after three years of construction, at the widest point of the Hudson River. Eight underwater concrete caissons support 70 percent of the bridge's weight. The caissons are supported by steel piles driven into rock and incorporate a buoyant design that stores pressurized air within small compartments. Pumps regulate the buoyancy of the caissons, and water is periodically pumped out of these compartments to achieve the desired buoyancy. This creative design saved millions in construction costs.

In addition to 42,702 cubic yards of concrete, a total of 303 miles of timber piles, 62.5 miles of steel, and 6.3 miles of 30-inch steel pipes filled with concrete were used to construct the foundation of the bridge.

Plans are now underway to either renovate the Tappan Zee Bridge or construct a new one since it was only intended to last for 50 years. It is an amazing sight to behold, particularly at sunset . . . and from the right vantage point.

Sunnyside

Washington Irving once referred to his house as being "as full of angles and corners as an old cocked hat," and surely the charming, wisteria-draped home of the renowned author is an original. Irving purchased the 24-acre estate in 1835 and began to remodel it, adding weathervanes, gables, and even an oriental-style tower.

The unusual home reflects Irving's expansive personality, numerous talents and interests, and his passion for travel. He carved out a successful career as a historian, humorist, and travel writer, but had also lived abroad for several years as a diplomat in Spain and England. It is difficult to believe that the Sunnyside of today was once a rather ordinary stone cottage on Philipsburg Manor owned by members of the Van Tassel family whose name was immortalized in "The Legend of Sleepy Hollow."

Washington Irving was born in New York City in 1783. His parents, supporters of the Revolution, named him after the general who led America to independence. In 1800, when he was seventeen, Irving went on a Hudson River sloop bound for Albany to visit his two older sisters. On the trip he absorbed the sights and sounds along the way and later he used them to great effect in his writings.

In 1809 after the death of his fiancée, Matilda Hoffman, Irving spent time at the estate of a friend in Kinderhook in Columbia County. It was there that he wrote *A History of New York*, describing the lives of the early Dutch settlers in Manhattan. He wrote under various pen names, the most renowned being Diedrich Knickerbocker. In later years, the name Knickerbocker became synonymous with a person from New York.

Irving's most famous tales are "The Legend of Sleepy Hollow," which takes place in the Hudson Valley, and "Rip Van Winkle," set in the Catskills. From 1815 to 1832 he traveled through Europe and continued to write. A few years after his return to New York he purchased Sunnyside. Remodeling the simple farm cottage on the property took up a great deal of Irving's time during the following years and he personally supervised the renovations. An original thinker, he wasn't averse to combining Spanish, Dutch, English, and Gothic styles, making his "snuggery" quite an eclectic creation.

By the late 1840s railroad tracks had been constructed along the Hudson River as far north as Peekskill. Washington Irving's friend, Gouverneur Kemble, convinced Irving not to stand in the way of progress and allow the railroad to cut across his land. After receiving stock in the New York Central and Hudson Railroad, Irving granted the line permission, but he came to regret the decision due to the noise from the engines and the fumes from the smokestacks.

Sunnyside played a role in the Romantic Movement and Hudson River School of artists and writers. Thomas Cole, Asher Durand, and William Cullen Bryant were just a few of the prominent people who visited and enjoyed the rustic landscape surrounding Sunnyside. In later years, Irving's iconic home was publicized throughout the world in lithographs and magazines, as well as on cigar boxes, sheet music, and ceramic pottery.

The book *Wolfert's Roost* (Irving's nickname for Sunnyside) appeared in 1855, a collection of his Knickerbocker sketches; it was the last work he wrote about the Hudson Valley. The final years of his life were spent finishing his five-volume *Life of George Washington*.

Irving never married and had no children. He shared Sunnyside with his brother Ebenezer and his five daughters. During the early 1840s Irving served as the American ambassador to Spain, but otherwise lived at Sunnyside for the remainder of his life, surrounded by family and friends. Irving died in 1859, but the property remained in the Irving family until 1945 when it was sold to John D. Rockefeller. Two years later it was opened to the public, and the property still operates as a historic house museum. Sunnyside is located in the village of Tarrytown, incorporated in 1870. Some considered Irving's property to be part of Irvington, known as Dearman until renamed in Irving's honor in 1854.

Washington Irving is regarded as the father of Hudson Valley literature. In his introduction to *A Book of the Hudson*, published in 1849, he sums up his feelings for the region: "I thank God that I was born on the banks of the Hudson. I fancy I can trace much of what is good and pleasant in my own heterogeneous compound to my early companionship with this glorious river."

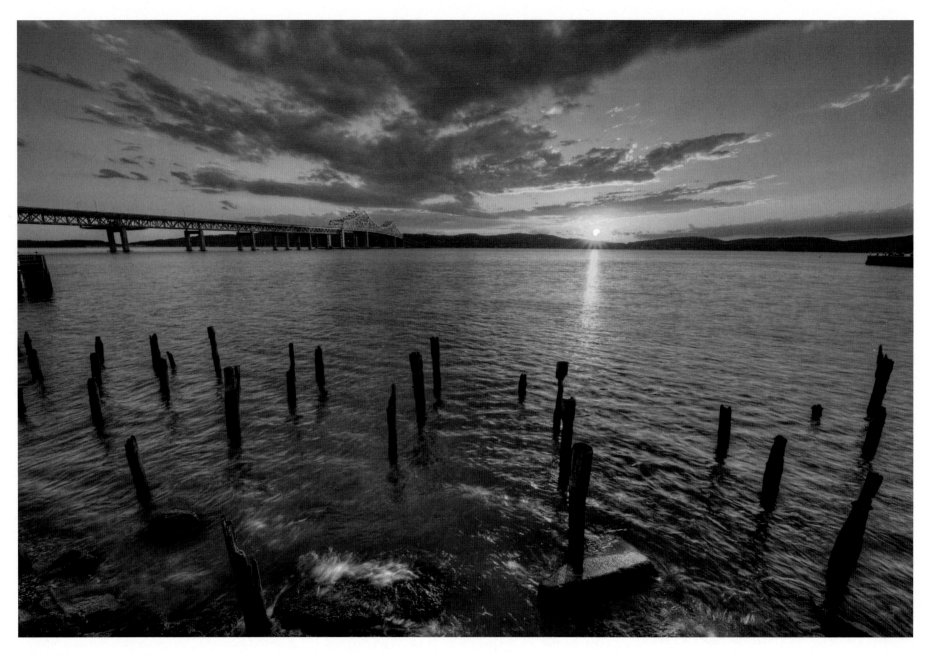

Sunset Cove, Losee Park, Tarrytown

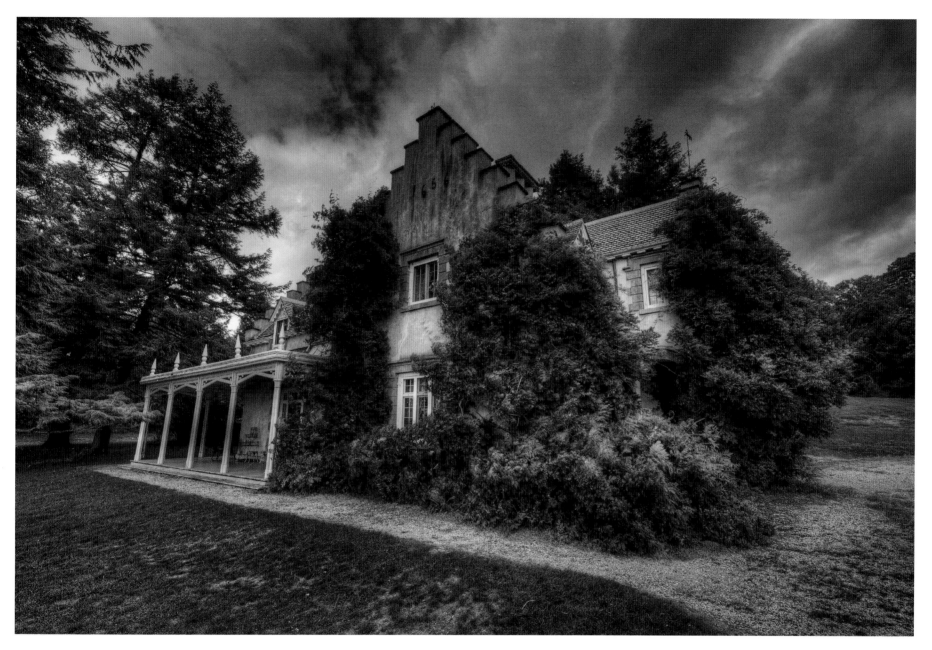

Washington Irving's Sunnyside, Tarrytown